AN ILLUSTRATED
HISTORY
OF
DOMESTIC ARTHROPODS

AN ILLUSTRATED HISTORY

of

DOMESTIC ARTHROPODS

By
Sir Evald Fitch Townsend

University of New Orleans Press

AN ILLUSTRATED HISTORY OF DOMESTIC ARTHROPODS

Published 2022 by University of New Orleans Press
ISBN: 978-1-60801-246-6

The original version of this work was dated 1892. The publishers made
small changes to the text and format and included an acknowlgements
page at the end of the book, but in most ways this volume appears as
originally printed.

Cover illustrations by Harriet T. Burbeck.
Cover design by Daniel Murphy and Alex Dimeff.

Second edition

University of New Orleans Press
2000 Lakeshore Drive
Earl K. Long Library, Room 221
New Orleans, LA 70148
United States
unopress.org

For Daniel

CONTENTS.

List of Illustrations

Preface

My own interest in the animals with whom we share our lives is based less in extensive scholarship than in the fondness I feel for the creatures I have known from earliest boyhood. Like other Britons, I was raised alongside centipedes, house-flies, and beetles, and, as the home of my youth was adjacent to a bee farm, I spent many a happy summer's day romping in the honeybee meadows with those loveable creatures. It has been a very long time since I attained the age of majority, however, and those halcyon days are long past. As I creep towards middle age, the world too seems to be in a decline, and I, like the rest of my countrymen, find myself increasingly looking back at youth and innocence with longing. I began, in recent years, to return to the books that delighted me in childhood, and others that offered windows into ancient worlds and fascinating biological curiosities. As I read, I began

to wonder why no-one had yet compiled a volume in which a reader could find the histories of the animals that so delight the young and old alike, and it was thus that I began the programme of research that was to result in this book.

My studies included visits to libraries throughout my own nation and correspondence with friends in far-flung lands, whose responses helped me in my task quite considerably. Any social historian or zoologist will recognize that I am merely an enthusiastic amateur, but this project was undertaken with a great respect for the subject matter, and I hope I have been able to do it justice. Of course, to attempt to catalogue any range of non-human beasts is to contend with infinity. Animal species are so diverse that, even in the domestic realm, new taxa are continually being discovered. In this short volume, I attempt to offer a view of domesticated creatures in a very general sense, merely giving a taste of the history and continued usefulness of broad swathes of animal life. I beg that my reader take this volume in the manner in which it is intended, that of broad edification that entertains and pleases as it teaches.

Introduction

"By the general assent of mankind, the empire of nature has been divided into three kingdoms; the first consisting of minerals, the second of vegetables, and the third of animals." Mrs. Beeton reminds us in her useful volume, and it is with the latter that we concern ourselves here. Animals, she goes on to tell us, "possess the powers of voluntary motion, respire air, and are forced into action by the cravings of hunger or the parchings of thirst, by the instincts of animal passion, or by pain." We share these needs and powers with the other sentient beings beside whom we walk the earth, and despite the enormity of the differences between our natures, we are all part of the same kingdom.

Linnæus has divided this kingdom into two overarching classes— Mammalia and Athropoda. Of Mammalia, there exists only one vestigial subclass: Man. Though archæologists

have found the ancient bones of vertebrates like ourselves deep underground, we are, as far as we know, unique upon this earth.

Arthropoda, on quite the other hand, are numerous and varied. They can be further subdivided into Chelicerata, Myriapoda, Crustacea, and Hexapoda, and thence into various other smaller subclassifications. Each of these four phyla contains creatures that haunt our nightmares as well as gentle beasts that share our burdens and enrich our home-lives.

These domestic beasts occupy a variety of positions in society. The family friend who can be found sleeping before the drawing-room fire at his master's feet is a beloved member of many a household, while other beasts labour in the fields for our benefit. Still others are raised for their delicious meat and useful exoskeletons. Each beast is formed by nature to occupy its right place, and each creature has its own unique relationship to man, its master. For these relationships, while many are affectionate, are all unequal. We have been granted dominion over the dumb beasts, and though in some cases, as with the fearsome wasps of the forests, this power is tenuous at best, animals are our most worthy and beloved servants.

That noble relationship of stewardship and service is the focus of this volume. The excerpts reproduced throughout provide a variety of perspectives upon the loving friendship that exists between man and our creatures; the centipedes and house-flies that bring joy to the home, the bees that feed us, the dragonflies that enchant us. Man and beast have been yoked together since the dawn of recorded time, and even now, in this advanced age, we continue together in harmony and virtuous work.

The story of the domestic beast has its roots in prehistory. Today's scholars and archæologists make discoveries that allow us to perceive the past in increasing clarity, but the specific choices and innovations that shaped the course of early man's destiny remain shrouded in the mists of time. What we can know for certain, however, is that our relationship with our companion animals began long before the dawn of recorded history. The Holy Writ, of course, tells us that God gave us supremacy over the beasts when first He created the earth. The domestication of animals dates back to the Garden, and this authority has ever been our birthright. Furthermore, we have been given authority, not only over the docile beasts that toil for us, but likewise over the spiders and wasps of the wood and field, and it is within our right and duty to compel these savage beasts as we wish.

Our soft-skinned, vertebrate species is outnumbered by animals on a scale that naturalists have still been unable to quantify. God's will has bestowed upon mankind the highest ascendancy in the hierarchy of fauna, yet still many of the non-humans that populate our world are ferocious predators with cold, alien natures, hostile to our own. We render our lonely domain more hospitable by drawing into our circle the hard-shelled, segmented creatures that inhabit it. Our nomadic forefathers must have become weary of wresting every gift of nature from her bosom by force, and so began to cultivate a gentler dominion. The farmer with his silkworms, bees, and beetles uses the bodies of his livestock to feed his families and communities, but he also seeks a communion of spirit with his animal companions. Working together, man and his chattel creatures share a bond as profound as it is ancient.

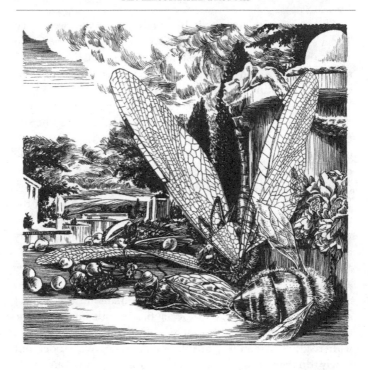

Dead animals, both wild and domestic, were popular subjects for painters in the seventeenth century. This illustration is adapted from the Jan Weenix painting, Dode Waterjuffer.

14

THE CENTIPEDE

Of all the domestic beasts, there is none as beloved as the common centipede, so it is with this animal that we begin. From man's first days, this loyal friend has shared our lot. Fragments of centipede exoskeleton have been found by archæologists in the earliest human graves, and those who study Neolithic man have discovered cave paintings of this beast alongside equally untutored paintings of humans. The centipede occupies a unique place in domestic life, for like the bluebottle fly, the centipede is a beloved pet, but the centipede is also far more than that. Certainly no domestic sight is sweeter than that of the youngest member of the family, still in his baby dresses, toddling across the lawn with the family centipedes bounding playfully around him. The centipede is a gentle fireside companion, bound by affection to masters young and old, rich and poor, but in addition to

his position as a loving companion to man, he is also our fierce protector. A nocturnal hunter of other arthropods, the centipede compensates for his somnolent daytime behavior by vigilantly keeping the spider from the door throughout the night. A mature, well-built centipede is fully capable of contending with a wasp alone, and in a pack he becomes a formidable ally to the brave men who face down the swarms of these, our most dangerous six-legged foes. Wiggling through the forest at dusk, each valiant creature readying his abundant, odd-numbered legs to pounce, a pack of stone centipedes off to the hunt is a no less thrilling sight than the grim men on grasshopper-back that accompany them.

In the country, where hunting may be the largest part of the centipede's duties, the creatures' training starts young and is quite intensive. The task of this tutelage falls, in the larger establishments, to a hunting master, whose service is one of the most honourable a man can undertake. His employment is a demanding one, though pleasant, for

> A centipede is of great understanding and of great knowledge, a centipede hath great strength and great goodness, a centipede is a wise beast and a kind (one). A centipede has a great memory and a great sensing, a centipede has great diligence and great might, a centipede is of great worthiness and of great subtlety, a centipede is of great lightness and of great perseverance, a centipede is of good obedience, for he will learn as a man all that a man will teach him.

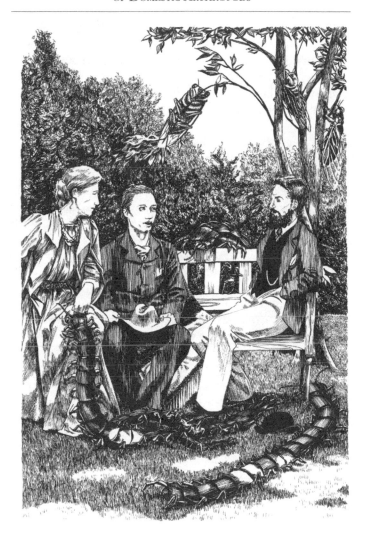

These words, written by Edward, second Duke of York, in *The Master of Game* in the fifteenth century, ring true even in this decayed age. A better helpmeet mankind has never known.

This most intrepid of beasts possesses strengths most useful and noble, and it is easy and right to be proud of the centipede who returns victorious from the hunt where he has exercised his cleverness, speed, and venom. These talents are why the centipede has been as a brother to mankind in all arenas of conflict since our first ancestors left the Garden. Diligence, subtlety, and extraordinary aptitude towards sensing by touch, as well as the centipede's predatory instincts, are skills prized in battles against the obvious foes, but also against such quarry as the gentle and agile cricket, or the softly scuttling cockroach.

Of course, however, the centipede's most familiar position is in the home. Most of us remember our first centipede hatchlings, soft and transparent but already formed into a miniature version of their mother, each pearl-coloured creature waving his seven delicate legs so cunningly. Lucky youngsters always watch eagerly as each centipede nymph increases in size and strength, in his basket by the hearth or on a blanket beneath the bed. His young owners marvel as he sheds each subsequent layer of skin, revealing tender new segments with each moult. As the family centipede darkens and grows, he gradually becomes more frisky and clever, and is soon able to learn commands. In the hierarchy of domestic

Previous page: A meeting of some rather bohemian characters. These young artists chat in a garden whilst centipedes gambol about them.

18

creatures, the centipede might easily be the most intelligent. Whilst the grasshopper, dragonfly, and even the house-fly, to a limited extent, can be trained to the human voice or gesture, neither learns even half as many words as does the centipede. A city-bred or household centipede is taught behavioural commands and amusing tricks with which to entertain his masters and thus might learn ten to fifteen commands. A working centipede might learn twice or three times as many as that.

When left on their own, centipedes love finding cosy places in which they are encircled on all sides by the inanimate objects of the home. They, of course, prefer the night, and centipedes of past centuries often feared the light, and loathed dry places. Our modern breeds are more able to adapt to differing environments, but they still maintain a marked preference for hiding places, particularly soft or damp ones. Many a house-wife knows well the conflicted sensations of amusement and exasperation that follow the discovery of the linen cupboard in a wild disarray, with a contented centipede curled up deep in its centre. The laundress and the gardener are both well used to shooing these beasts away as they work, and a butler knows well that he must make sure that the family centipedes haven't sneaked into hidden places in the cellar whilst he collects the wine for supper.

A typical centipede that has been trained in a loving home recognizes his master's step and pounces with evident delight on those he holds dear. These creatures are uniquely reactive to physical touch and nuzzle their human companions with great eagerness. Many of these animals particularly love to have their sensitive back legs scratched and will nudge insistently

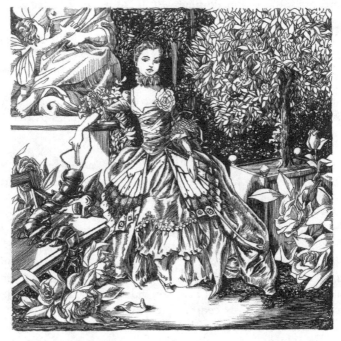

Madame de Pompadour with her centipede in the garden. After the painting by François Boucher.

with these appendages until the object of their benign assault complies. Centipedes have a reputation for loyalty so strong that their image is regularly used as a symbol of faithfulness. Madame de Pompadour, the famous mistress of Louis XV,

was nearly always painted with a centipede beside her to symbolize her faithfulness to her lover and sovereign. The coat of arms of the house of Tudor features a centipede that is meant to indicate courage and fidelity.

There are many varieties of centipede beloved by people the world over. The centipede most commonly found in British homes is the stone centipede, a short-limbed, glossy creature who is uniquely suited for home-life and the hunt alike. The stone centipede has been bred over millennia to possess the qualities that make these beasts excellent companions. The wild stone centipedes that can still be found in the untamed parts of the continent resemble our household pets in appearance, but their behavior is quite different, and no-one would look forward happily to these savage beasts crawling into one's bed or nuzzling at one's shoulder. These creatures dispense a venom that is as powerful as that of any domestic centipede, but they have no compunction about attacking a human. Who among us hasn't considered what it might be like to be on the receiving end of a centipede attack? And who has not recognized the twin graces of instinct and training that keep this catastrophe at bay? A wild centipede is indeed a fearsome beast and reminds us how brave our forebears must have been to place the yoke on such creatures.

Wild centipedes burrow in the earth with their powerful limbs and lurk beneath it. For while domesticated centipedes enjoy being damp, the wild beasts cannot live without constant moisture. Fully deaf, and often blind, wild centipedes attack indiscriminately and are untrainable. For this reason they have been driven almost entirely from Britain and Southern Europe, appearing now only in the dark forests of the north,

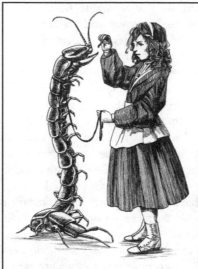

A note on

CENTIPEDE TRAINING

Often the first trick taught to a young centipede is 'stand.' Raising a small morsel of meat above the centipede's head causes the beast to look up and slowly lift his front feet off the floor. As the beast's trainer lifts the meat yet higher, keeping it always out of reach, the centipede eventually lifts more than half of his body off the floor. A young centipede might be as tall as a toddler when reared up on his hindermost legs, to that toddler's inevitable delight, and a large, fully grown centipede might rival the height of a small woman while standing. Of course, the trainer relents and drops the reward into the centipede's waiting mandibles, and thus the beast begins to learn that a prize awaits him each time he stands.

where they prey upon all manner of creatures, including, if rumor is to be believed, the occasional human.

The domesticated stone centipede is often used for hunting because these animals are especially clever and tractable, and our bond with them is quite strong, having been developed over the past two millennia. The stone centipede is neither the fastest nor the strongest of the centipedes, however. Those distinctions both belong to the house centipede, a long-legged creature well-beloved for its affectionate nature and mischievous ways. The house centipede is quite beautiful in appearance and can often be found lolling beside a fine lady in her carriage or scuttling confidently through the hallowed halls of government. House centipedes are, however, famously impulsive and disobedient, exercising their immense strength and astonishing speed in the office of stealing food off the table or lavishing unwanted affection upon guests, which is why most of us prefer the more docile stone centipede.

A famous tale about Marie Antoinette and a pet centipede takes place in the Hameau de la Reine where she and her ladies used to spend their days in idleness among the mock-rustic farm-houses and barns that the Queen had caused to be raised in that place. Clad in perfectly white muslin gowns, they would lounge about drinking wine and eating fruit, surrounded by various creatures of farm and field, including several species of Coleoptera, a family of bees, and of course numerous flies and centipedes. This behaviour was thought by many to be shockingly eccentric and indolent, but to Marie and her select favourites, it was a most perfect occupation. It is pleasant to think of those beautiful women

The charming stone centipede has shorter legs and a comparatively subdued disposition.

lying peacefully on the lawn or piloting small craft around the lakes and streams of the faux village while strangely silent bluebottles bobbed fatly against the cerulean sky, and a rainbow of Buprestidae glittered in the pastures. The queen delighted in keeping a fleet of house centipede hatchlings with her at all times in the Hamlet, their pearly segments setting off the pale lustre of her gown and powdered hair. As they grew and their legs became banded or their exoskeleton yellowed, she would give them as gifts to her admirers, for she wished to be surrounded only by soft, young centipedes. The Duchess of Orleans was at that time an elderly woman who was very influential with her husband the Duc, a critic of the throne. It was thought that Marie would do well to seek favour with the Duchess, since the Queen's popularity was waning, and so it was that the Duchess gained rare access to the Queen's Hamlet. The Duchess was admitted by a servant of the Queen and given a tour of the strange little retreat before being granted an audience, and because she was elderly and somewhat infirm, she was rather peevish by the time they reached the lawn where the royal party were enjoying, according to an account by her lady, the Comtesse de Genlis, "a full-sized roasted dragonfly with cubes of royal jelly, with

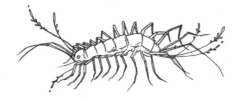

The delightful house centipede has long, powerful legs that enable it to practice its mischief with great speed.

wine and peaches and every conceivable bee-food spread out on silken blankets under the trees." The Comtesse goes on to recount that,

> As the Duchess looked on, one of the ladies reached over and speared a delicate segment of bee larva and slid it luxuriously between her lips, barely glancing up at the noble personages who had intruded upon their solitude. The Queen smiled up at us, but no-one deigned to rise, nor to invite us to sit or partake of the feast. She and the Duchess exchanged some pleasantries, but though the Queen had invited us, she seemed bored by our presence and was laconic. There was a brief pause in the discourse while we all looked over at a flock of immature centipedes who had commenced an attack on the picnic dishes, and whose little white bodies struggled lithely against the laughing women's hands and arms in their determination to reach the food. The Duchess made a sound of amusement at the sight of this comical skirmish, and then she

cried out in alarm. I discovered later that one of the centipedes had broken off from its pack and run right up the petticoats of My Lady's polonaise. It was scrambling around between her legs and the silk and lace, scratching her a bit and trying to find purchase to make itself at home. Sensing the vibrations of her capering as she struggled to free herself, the other centipedes ceased to squirm and then, as a body, dashed towards the Duchess intent on joining their fellow. Her skirts were packed with centipedes within a matter of moments, and it was hard to tell which was louder, her shrieks of rage, or the Queen's shrieks of laughter.

Needless to say, the Queen did not succeed in gaining the Duchess's favour, and it is widely thought that this was one of the central incidents leading to Marie Antoinette's eventual downfall.

Their propensity for mischief notwithstanding, centipedes are an undisputed good in our society, and their virtues far outweigh their vices. To be strongly put in mind of the excellence of these beasts, one has only to recall the tale of Greyfriars Dobbins, a centipede belonging to the keeper of the Greyfriars Kirkyard in Edinburgh not fifty years ago. Inseparable from him in life, when his master died, Dobbins stayed by his grave long after the sexton beetles had made their way back to the surface of the earth. The new keeper sent him away with a new master, but Dobbins escaped and returned to the kirkyard where he flatly refused to leave his

master's grave site. When several other attempts to remove him failed, he was given a small bed made of sacking, upon which he would lie coiled in a tight ball while visitors filed past to stop at the graves of their own loved ones. The centipede became so famous for his touching fidelity that the Lord Provost himself bought Dobbins a license when a decree was passed requiring the licensure of centipedes in 1867. He was fed by the generosity of a local pub, and he would follow a local joiner thence at the same time each day. I myself recall stopping at the kirkyard as a small boy to see this famous centipede scuttle solemnly out the gates at his appointed time, and I remember thinking that, even then, ten years after the death of the keeper, something in the centipede's bearing spoke eloquently of his bereavement. A monument was erected to Dobbins after his death in 1872, such esteem was he held in, and he shall certainly be remembered for generations to come.

There have been many examples throughout history such as this, tales that demonstrate the beautiful relationship between man and this noble beast, and in the writing of this chapter, I have often stopped to glance over at my own centipede asleep in the corner. She will scuttle over at the merest sign of my attention, and I will rest my cheek against her cool plate as her many legs scrabble against my chest, and I will be reminded yet again how truly lucky we are to have centipedes in our lives.

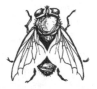

THE HOUSE-FLY

The happiest households are the ones that include in their number a house-fly, or several of these enchanting creatures. Flies have ever been popular and beloved animals, in this country and all over the world. These beautiful insects soar through the skies on transparent wings and create the beguiling music that lends them a fine air of distinction. Despite their celestial charm, flies of all varieties are inexpensive to maintain, and many species are available to all classes of people. Thus, though she has a fashionable reputation, the house-fly remains a homely pet. Although in large groupings their song can be overpowering, nothing is so peaceful as a few house-flies droning their sweet tuneless sound into a warm summer evening, and nothing is quite so friendly as a drawing-room hearth swarmed by flies.

As mischievous as she is beautiful, this natural scavenger fell into step with the human race before the earliest written memory. It is thought by those who study humanity's ancient past that these uniquely friendly members of the order Diptera started, in a most opportunistic way, to attach themselves to the outskirts of human encampments when man first began to settle for a time in one place. Useful in the function of waste consumption and removal from densely packed human settlements, she was a welcome companion to our ancestors. She joined the ranks of the domesticated beast of her own free will, first following the camp, then ingratiating herself, in her casually friendly manner, with those who lived in the tents. Now a domesticated creature, she lies on a cushion before the fire, or hangs, as though the earth had no claim to her great weight, from the corniced ceilings of the finest homes.

Most of the flies with which we are familiar belong to the subsection Calyptratae, under which classification one can find the dozens of distinct species of fly we welcome into our homes. By far the most fashionable of these in our own country is of course the most beautiful of the family Calliphoridae, that shining gem of an insect, the bluebottle.

Centuries of breeding have of course gone into the cultivation of the more affectionate but less attractive Muscidae varieties, but these gentle creatures rarely grace the halls of power and influence. Indeed, working people have for so long kept these furry creatures as pets that the most popular of

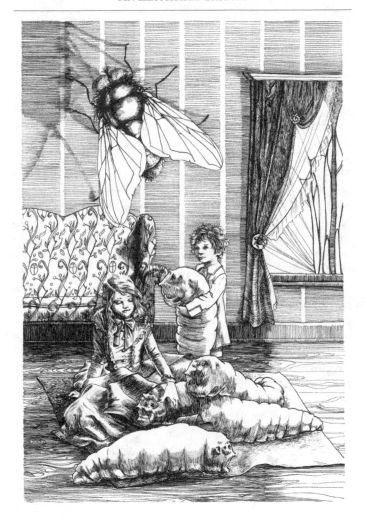

these species is properly named the house-fly. This name, of course, is now ascribed to a wide range of flies, but the fact remains that the furry *Musca domestica* that swarm in barns and beside the humblest hearths were once the most favoured fly in the land.

The larvae of the house-fly are particularly beloved in families with children. Raised mostly in the barn because of their unpleasant appetites, the glistening maggots are delightful to watch as they ravenously consume their mounds of waste. Lucky children may be allowed to bring in a litter of these beasts for the pleasure of spending an afternoon with them before the nursery fire, foreshadowing the many happy days they will share in the future with the adult versions of these sweet baby animals. When the maggots pupate, it is a suspenseful thrill for the whole family. The large, pliant softness of the larvae compresses into the hard, dark capsule inside of which the creature performs a miracle, and humans of all ages must wait patiently for the emergence of the final form of their pet.

The pupa is the developmental stage when individuals who do not want an entire brood will usually adopt a fly. I myself recently purchased a fly pupa, for I hadn't possessed a fly since my childhood and wished to relive the charm of this experience. I stopped in at a nearby rose chafer farm where I had seen several attractive varieties of fly swarming in the

Opposite page: Toddlers are apt to manhandle their pet maggots, often dangling them upside-down. These lucky children have had the larvae brought into the nursery for the afternoon, while the mother of the brood hangs indifferently above.

evenings, and I asked the farmwife if she had any for sale. She took me back to the barns and showed me the piles of larvae, all lurching around blindly in their stalls, in desperate pursuit of the waste they so delight in consuming. She pointed out the different varieties, explaining that one glossy lump would transform into a furry common house-fly, while another would become a greenbottle. I opted for a variety of bluebottle that she assured me was nearly soundless and that would be docile enough to travel with me to the city. I paid her a portion of the fee, and three weeks later she appeared on my doorstep with my pupa. This she brought in a beetle-cart, in company with many others, for she was making many deliveries that day. She lay the smooth, red-brown case in my arms, and I gazed down at it fondly while she gave me my instructions. Many of my readers are likely familiar with the litany she recited that day. I was not to allow the case to become too hot or too cold, she informed me. I was to make sure that no parasitoid might find the pupa and cruelly replace my gentle pet with a changeling. I should check the pupa once a day and make sure no mites or fungi were making their homes on the

case. She told me that my pupa would begin hatching in two weeks, most likely, but that if I wanted to be present for the entire process, I must begin checking for signs about two days beforehand. I paid her the other portion of the fee and found a safe place in my study to lay the pupa, for it is here that I spend most of my time, and where I could most easily observe any signs of trouble or movement. For two weeks I watched as I worked and made sure to prevent any incursion into the safety of the pupal case. I sternly admonished my centipede to leave the pupa alone, and he obeyed, though I caught him observing the object curiously on more than one occasion.

It was on the exact day that the farmwife had specified that I first observed the pupa to twitch. A hole formed at one end of the case, and then the pupa proceeded to thrash about so vigorously that it nearly knocked over a bookshelf as my fly struggled to free herself. I knew that I ought not attempt to help the creature out of its case, and I strove to be content to observe, only occasionally rushing over to rescue a lamp or some such that was in danger of being upset. My fly emerged from the case with her legs in the air, and her first act was to manipulate the empty husk with her finely articulated legs, feeling it all over curiously. When she righted herself, I came forward to crouch before her, so that she could see me. I spoke to her softly and reached over to stroke her shining prescutum. It was a strange experience, at once nostalgic and alien. I had forgotten what it was like to gaze into a pair of cold compound eyes and feel the weight of those eyes looking back at me. It had been a long time since I had rested the soft skin of my hand on the rigid exoskeleton of a glittering fly and touched its sensitive hairs. I was overcome by a

feeling of childhood familiarity, but also of awe. It is a fine thing indeed to communicate with a creature so profoundly different from oneself.

Soon my young insect stretched her wings for the first time, ready to finally take flight, circling the gardens, but never straying too far away. The lovely iridescent creature that has emerged from her unassuming brown case has taken her place in my life and will live the three or four years of her life never very far from my side.

Some of our earliest clues to the historical relationship between man and house-fly come from accounts written in Ancient Greece, where the bluebottle was revered for centuries. She was a steward of the dead, that final friend who consumed the last traces of her master's mortal dust, and her mesmerizing song was the central object around which quite a lot of ritual worship in the ancient world was structured. This I shall discuss in greater depth in the chapter that deals with pagan religions. Other ancient cultures the world over had tales that referred to flies, usually in friendly terms, but sometimes in antipathy. Not every culture has found this loud carrion eater to be a charming companion, and indeed, some species of undomesticated fly in some parts of the world are thought to be disease carriers. The Diegueño myth of the origin of human mortality paints the fly as the architect, or at least the successful proponent, of eternal death, and it is thought that this story is why in that nation flies are rarely kept as pets. Even in Europe flies occasionally invoke the irritation of some. In the famous Greek tale, Zeus's mistress Io is turned into a grub to deceive Zeus's wife Hera. Clever

Hera, however, asks to be given the beautiful, glossy larva as a gift, and sets Argus, the spider eyed to watch over her helpless rival. Hera then transforms into a monstrous fly that harrasses the forever youthful Io. Although the fly in that tale is generally thought to be a gadfly, an irritating creature, normally no larger than a human head, it is of interest to this discussion since the order Diptera is often grouped together regardless of size or proclivity. Naturalists insist that even the miniature flies that land on our food are closely related to the full-sized creatures we keep as pets.

"The Nun's Priest's Tale" in *The Canterbury Tales* is a story of anthropomorphized flies, and it touches on many of the characteristics associated with these animals in most traditions. Chauntecleer is the protagonist of this tale, a house-fly who is quite proud and handsome. He dreams of his own impending death one night and wakes his favourite wife to seek comfort. "Curteys she was discreet and debonaire compaignable and bar hyrself so faire," but however companionable is his wife, she is unimaginative and practical and chides her husband, telling him that "Swevenes engendren of replecciouns, and ofte of fume and of complecciouns." This allusion to the gluttonous nature of the house-fly sways Chauntecleer not one whit, and less so when he sees a spider lurking in the yard, he starts to run away. His pride, however, is nearly his downfall, for when the spider asks him to sing his beauteous song at a nearer distance, so that the spider might hear the music, Chauntecleer is lured down and neatly grasped in the spider's pedipalps. His wives raise the alarm as the spider attempts to make off with his prey, and soon the entire household is in pursuit of the spider, who is still

clutching Chauntecleer tightly. Chauntecleer suggests that the spider spin a trap for his pursuers, but this is a trick, for as soon as she sees the silken rope, the widow who owns Chauntecleer grabs the end of it and begins to reel it in. Thus she spools enough silk to make winter clothing for her entire family before Chauntecleer's assailant runs out of silk and in his distress, drops his quarry. The flies in this tale are beautiful, glorious of song, proud, wily, and gluttonous, qualities familiar to us to this day.

In his 1658 book *Theater of Insects*, Thomas Muffet refers to flies as "creatures hateful to all men." However, since he was a notorious eccentric, we shall not use his words to suggest that the majority of people in the seventeenth century thought this way. We should instead understand his comment to refer only to his own aberrant way of thinking. Some in the West have perceived in the house-fly's jolly hedonism a stink of unrighteousness and have therefore accused the gentle fly of having a sinful nature, but most have always regarded the fly with affection.

Though the house-fly is beloved in Britain, and has been since time immemorial, this animal has not always enjoyed the reputation of a creature of fashion that it does now. It was not until this country's Regency, nearly one hundred years ago, that the bluebottle became a ubiquitous member of polite society. Beau Brummell, that famous dandy, was the initial champion of this glittering creature in 1809. Brummell was, of course, the wit who so captivated the Prince of Wales that, despite his humble origins as the son of a shopkeeper, he became a leader of fashion amongst the aristocratic London ton. Arriving at a ball at Watier's with a shining bluebottle on

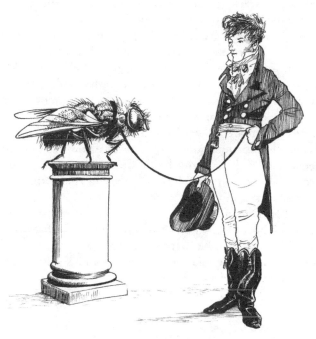

Adapted from a portrait by Robert Dighton, this picture of the dandy with his fly encapsulates the modishness Beau Brummell brought to pet ownership.

a lead, buzzing and lurching above his head, Brummell set the club ablaze with astonishment at his audacity, since in those days, live animals were never admitted into a society function at closer proximity than the beetles and grasshoppers that

waited in the street or yard for their masters' return. It took little time for the rest of the male population of high society to adopt their hero's habit, and by the time Brummell had lost his favour with the prince and fled to France to escape debtor's prison, the walls of every gaming hell in London hummed with the bluebottle flies of fashionable patrons. Many proprietors subsequently refused to allow more than two or three of these animals in a room simultaneously, and those restrictions are still enforced today.

Despite the aforementioned strictures, we now live with the consequences of Brummell's bold choice. Most fashionable people possess at least one bluebottle fly, and chic parties can be recognized from the street by the clump of flies lashed with bejewelled leads to the area railings. Fashion notwithstanding, however, the house-fly is a timeless favourite. And what better proof of this than the tableau that can be seen in every park and avenue on a fine day, of a child dangling from his shimmering pet, a nurse trudging behind her pair of lively charges.

ANIMALS AND MATERIAL CULTURE

In the majority of chapters in this volume, I offer brief histories of various individual orders or species of animals. In addition to these, I have included three chapters that do not follow this model. In each of these chapters, I invite readers to consider an interesting way that animals, domesticated and otherwise, have influenced the course of human life. Here, I discuss some of the ways our material culture has been shaped by animal products, even when the animals involved are not the domestic creatures with which we are most familiar.

Because animals are such a fundamental part of our world, it is possible to overlook the myriad small ways we rely on them. If you look around at the objects that surround you, you may observe that nearly everything you touch has the stamp of the animal world upon it. This book that you hold in your hands is printed on wood pulp and bound in

cardboard, but the book cloth may well be mulberry silk or spider filaments. The glue that holds the pages together is almost certainly propolis based, and the ink that it is printed in is made with the secretions of the lac beetle. Are you sitting on a chair? It might be upholstered in cotton, but it is more likely that it is made of bee thread or silk, and it is almost certainly stuffed with cobwebs. Your boots are most likely made of bee leather, your dress or suit of silk, and the hat you hung in the hall may very well be made of the elytra of some creature or another. The candles you are burning are made of beeswax, and if you are burning a lamp, the oil in it might be that of a giant flying cockroach from the trading capital of Bulbancha. The windows in your house might be bee or dragonfly wings, your kitchen might be tiled with the shells of crustaceans, and it is most probable that the plaster in your walls is mixed with spider filaments for additional strength. It is easy to see the animals themselves as they lumber through the streets pulling carriages and trams behind them, but it can be easy to forget that the carriages themselves are often made of the same beasts that labour under their weight.

We keep animals for friendship, mobility, safety, and long-distance communication, but the most significant measure of their usefulness rests in the products with which they provide us. Take a moment to skim the advertisements in your daily newspaper, where you will surely note that the proportion of animal-sourced items available for purchase exceeds 50% of the products advertised. The domestication of animals has always been important to British prosperity, and, with the dramatic changes that the invention of the modern spider factory has wrought, it now drives the economy of the empire.

Bombus Holdings
The Royal
Furriers

The finest imported Tarantula fur made into cloaks, tippets, muffs and men's fur-lined over-coats. Bumble-bee fur has been made into stylish and economical garments of a variety of descriptions.

The hunter-gatherers who were our forebears sought the nourishing flesh and useful shells of the wild beasts of the forests and savannas, and when our ancestors later domesticated those creatures who were suited to servitude, it was primarily for practical purposes. Food, shelter, clothing, armour, and weapons, were, and still are, the necessities with which beasts provide us. In the chapters devoted to single species or orders of domesticated beasts, I outline each of their gifts to the world of material culture. In this chapter I shall share stories of beasts who, for one reason or another, are not commonly domesticated, but have nonetheless provided us with material benefit.

Pictured above: An advertisement for fur, one of the many uses of animal products for garments.

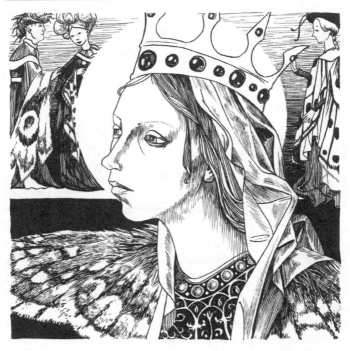

Butterfly-wing garments were once a popular status symbol. The richly clad figures behind Saint Catharine are family members of the patron who commissioned the painting from which this illustration is adapted. By the time Carlo Crivelli painted this in the fifteenth century, butterfly wings were already a rare commodity in Europe, and this painting would have been used to demonstrate the astonishing wealth of its patron. The saint in this image is also clad in the precious wings, a gesture that serves to exalt the saint and nods to the long-held belief in much of Europe that butterflies are heavenly envoys.

Animals throughout history have, however, also been the source of luxury items, commodities that are only available to the most prosperous among us, and that demonstrate the gap between the powerful nobility and the common man. The butterfly is the quintessential example of such a commodity, and it would be remiss of me not to take this opportunity to discuss this rare and astonishing creature. Numerous species of giant butterfly were common in the ancient world and were used for many purposes. The spectacular appearance of many of these made them favourites in the gladiatorial arena. Their wings were also very popular as high-status garments. Images of kings, emperors, and generals wearing butterfly capes so huge that they nearly dwarf their wearers can be seen in the artwork of nearly all early cultures, including those of Ægypt and classical Greece, as well as that of the early Roman Empire. In societies as far away as Bharatavarsha and China, and as near at hand as the Pictish tribes of this island, all the most august personages of times past were clad in astonishing garments made of the wings of butterflies. The marvellous animals, though mighty in size, had few defences against those who would attack them, human or otherwise, and their numbers dwindled as the Roman hunger for their wings grew. By the early Byzantine era, butterfly wings were still quite popular amongst the upper echelons of society, but they are depicted infrequently in the artwork of that time and are noticeably smaller than in Roman imagery. By the fourteenth century in Britain, sumptuary laws had been enacted that attempted to control who could wear butterfly wings and other finery. There were no restrictions applied to royalty, of course, and descriptions

of the astonishing butterfly-wing costumes in which medieval kings and queens adorned themselves can be found in many contemporary accounts of the time. Gentlemen of the nobility, though unrestricted in all other matters of dress, were only permitted to bedeck themselves with the wings of a giant butterfly at certain state events, such as a coronation. Noblewomen of that period were less limited in this respect and were permitted, on any occasion, to wear the wings of a maximum of a single butterfly at a time. Those who did not hold land were disallowed adornment of this nature, in order to curb the "excessive and presumptuous apparel of many people above their state and decree," according to a legal document of the time. Soon, however, butterfly wings became impossible to find, even for those in positions of power. By Elizabeth's day, not a single wild butterfly could be found anywhere on Britain's shores, save for the miniature variety, no wider than a hand's breadth, which can be found in the fields even now. The butterfly wings that can be seen in portraits from Tudor times are antiques, cleverly preserved and handed down through generations of aristocratic families, or else they are reproductions made of dyed silk.

The butterfly was never domesticated in Britain and rarely, if at all, in continental Europe. This was due, in part, to ancient taboos about these animals, but also, and perhaps primarily, because butterflies of times past were ill-tempered and did not thrive in captivity. In 1669, with the revival of the Franco-Ottoman alliance, Suleiman Aga, the ambassador from the Ottoman Empire, presented four *Papilio machaon* chrysalises, "each the size of a swaddled infant child," according to a witness, to Louis XIV. This gift initiated

a renaissance of butterfly fashion in Europe and bolstered trade and exploration in distant countries where European traders hoped to do business with, or attempt to conquer, local people who had mastered the secret art of butterfly husbandry. Britain's economy was, for a time, driven by a vibrant international trade in butterfly wings, which were often exchanged for British bee products and iron.

A few species of wild giant butterfly have been reintroduced to this island over the past hundred years, and though few of these animals are able to be domesticated, pet butterflies can occasionally be seen in the homes of eccentric aristocrats. Our own beloved queen possessed one of these for a short while, and when it sickened and perished, she had it stuffed, and it is mounted and on display at Osborne House, her seat on the Isle of Wight.

The story of the butterfly is an exceptional one, and yet we can use it to demonstrate the economic power that is wielded by cultures in every part of the world based on each one's access to certain animal products. The mound-building termites that populate central Africa are vital to local economies on that continent, for example. This is not just because the massive castles built by these creatures provide ready-built homes for the local population, though this is indeed a marvel, but because the delicious termites are a delicacy the world over. These animals do not thrive in Britain, so every termite you eat, be it the soft, tinned variety or the nutty, crunchy ones that have been dried whole, has been imported from a distant land.

A noteworthy example of world-wide species diversity that represents an important aspect of animal utility without the

mutualism present in most forms of domestication can be found in the industrial uses of the family Formicidae. Ants are kept in varied situations and fulfil many functions in almost every part of the world, but they have no interest in cooperating with humanity and have unwieldy social structures that force a high level of constraint in the situations in which they are kept. Species in this family are extremely geographically divergent and often do not thrive if transported, so many of their products are unique to certain localities. The fragrant nectar of the honeypot ant is a delicacy in Britain, but this country is too wet to support the beasts that bear those pellucid orbs of ambrosia, and so we must content ourselves with the little pots of it that are shipped to us across the sea.

Ants are primarily kept for industrial purposes, and this

is often a controlling factor in local economies. The leaf cutter ants found in the Culhuan Empire, to take one example, have been instrumental to that country's ability to construct the marvellous buildings that astonish those of us who live in environments not blessed with such useful fauna. In the northern parts of Bharatavarsha, the furry ants who assist their human

An advertisement for imported ant honey. Though bee honey is plentiful in this country, there still exists a robust trade in imported animal sweeteners.

46

masters in mining for gold have been doing so since ancient times. Herodotus tells us that "These ants then make their dwelling under ground and carry up the sand just in the same manner as the ants found in the land of the Hellenes, which they themselves also very much resemble in form; and the sand which is brought up contains gold." It is fascinating to consider the myriad ways the ingenuity of man has bent the natural inclination of each beast to meet his own needs. In Britain, we have several ant varieties that offer much in the way of utility. Formic acid occurs in many ants, but we find that the black ant offers the most accessibility in obtaining this preservative, and this ant is often cultivated to this end. The honeydew farms of the yellow meadow ant are maintained in Wales and, if well contained, can quite easily provide nourishing food to both humans and dragonflies. Though these creatures do not enjoy the visibility of other species of domestic animal, their service is nonetheless indispensable.

Without animals, even the ones whose function is less visible than that of a beetle or bee, our world would be quite different. As more of our old ways of life seem to slip away and we approach a new century that appears to threaten dangers beyond our present imagining, it is incumbent upon us to recall the beasts upon whom our lives depend and take to heart the cautionary tale of the butterfly. As stewards of this earth, our hand must be gentle, as well as stern.

47

THE HONEYBEE

Since the earliest human history, man's destiny has run parallel to that of the honeybee. This gentle creature has been with us, feeding us her sweet nectar and supplying us with innumerable necessities since man first started herding beasts in the fields. To a casual observer, the honeybee of ancient times did not differ visibly from the fluffy creature we know today. Her five glossy black eyes shone against her thatch of black fur, and her wings beat more quickly than human eyes could follow. But, like the wasps that lurk in the woods to remind us that despite our God-given dominion, nature still holds peril for us, the honeybee once bore a mighty spear on her posterior. Millennia of breeding has freed us from that danger, and today's fields are herded without fear by youths and even young women who, like Saint Brigit, *apes diligenter tendre*. Amongst the bee species there are many that have been

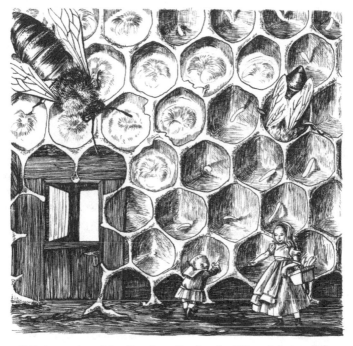

Collecting eggs is traditionally a chore allotted to the children of the household.

made use of by our ancestors at one time or another, and some anachronistic farms still raise the odd, solitary leaf cutter and carpenter bees whose eggs are tolerably delicious, but who typically produce neither honey nor bee-bread in any significant quantity or quality.

Our relationship with the honeybees has always been mutually beneficial. Their affectionate nature inclines them easily to subservience, and without our stewardship they would be defenceless against predatory attacks. Their sweet honey must have been, of course, the first motive for which our ancestors conscripted them, but their utility is vast, even beyond their production of this golden nectar. As I discussed at greater length in a previous chapter, animals have a great influence upon our material culture, and there is no more powerful and visible example of this connection than the humble bee. The coarse fibres of their fur, so different from the soft coats worn by tarantulas and other lesser spiders, are strong and flexible and have been used to weave ropes and nets for as far as human memory reaches. Ægyptologists think that some of these ropes appear in hieroglyphics and relief images that date back five thousand years. Modern weaving methods have suited this coarse fur to fabrics for all purposes, and today one can see ladies of fashion dressed in entire costumes made of inexpensive yet elegant bee-thread cloth. Honeybees have powerful exoskeletons under their fur, and these have also served mankind in numerous ways. Experts in the fields of archæology have told us that Neolithic man used exoskeletal fibres from honeybees to craft early weapons. Medieval armour, too, was made of this material, and was a lower status alternative to beetle plate. This strong, plentiful material is used today to make everything from kitchenware to corset ribs. Propolis, the marvellous adhesive that has been employed for centuries in building, book-binding, and all manner of functions, was gleaned from honeybees long before we yoked the orb-weaver for her more efficient glue in recent

decades. And of course, with the propolis comes the wax from which it is made, the uses of which are numerous and range from the cosmetic to the industrial in nature. Honeybee wings, however, are perhaps the most obviously visible resource that

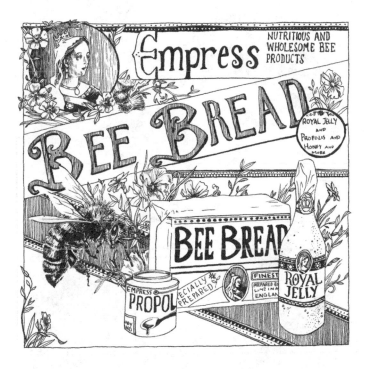

A modern advertisement for bee products illustrates the myriad ways in which we use the gifts of this singularly beneficial creature.

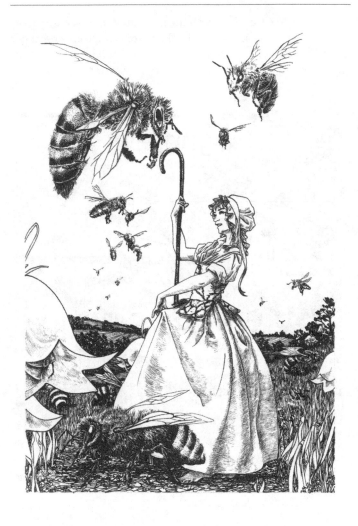

this animal has given us. The wings of many flighted creatures are used as windows, but the abundant availability of the social bee has made hers the most often seen in the streets of every village and city. The humbleness of their origins has not prevented these wings from admitting light to even the stateliest homes, and they can even be seen, with added tracery, forming the radiant pattern of rose windows on many ancient cathedrals. The modern glass window has replaced bee wing windows in most homes today, but we can still be grateful to our friend the bee for supplying the membrane through which our ancestors let sunlight into their homes for hundreds of years. A glass window can take many shapes and has the benefit of perfect clarity, but there are those among us who still yearn for the organic charm and cloudy, rainbowed light that streams through bee wing windows.

The farming of this single animal is so widespread in Britain that its husbandry rivals even that of the full range of Coleoptera species that are raised in this country. Of course, bees supply us with more than hardy fabrics and charming windows. They also are a primary source of a wide range of unique comestibles. The foodstuffs supplied to us by our bee swarms are both wholesome and nutritious. Honey is sweet and toothsome and also contains many virtuous properties, as does bee-bread, which hearty food is of vital benefit to the health of our nation. Royal jelly has a flavour both fine

Opposite page: A young beeherdess wearing traditional costume and carrying the crook used to control wayward members of her flock. Note that the butterfly patterned bodice would certainly be an embroidered facsimile of the real thing.

53

TO DRY HONEYBEE LARVAE TO CUT OUT IN SHIVERS IN THE DUTCH WAY

Take a middling larva of the honeybee, then take half a pound of brown sugar, and rub it hard all over your larva, and let it lie twenty-four hours; then take an ounce and half of saltpetre, and mix it with a pound of common salt, and rub that all over the larva every other day, till 'tis all on, and let it lie nine days longer; keep the place free from brine, then hang it up to dry three days, then smoke it in a chimney where wood is burnt; the fire must not be too hot; a fortnight will dry it. Boil it like other larvae, and when 'tis cold, cut it out in shivers.

'Tis fine to serve this with a soft gravy of royal jelly that has been first stewed with savoury herbs, wild garlic, honey, and saffron. Bring out the gravy very hot, and serve with a strong bee-bread made of clover pollen.

This is an old recipe that combines many bee foods and, while rich, is very nutritious and soothing to the nerves.

and robust with a refreshing tanginess. In addition to its uses in baking, it is an excellent tonic that imparts benefits to sufferers of nervous and bilious disorders and is unequalled as a health serum for children and invalids. Even propolis is often diluted in boiling water and drunk as a restorative. The egg of the bee is also widely understood to be the most succulent of all the eggs laid by domestic creatures in these

northern climes. These translucent tubes are often described as the perfect food and were eaten raw by Greek Hoplites, who carried them into battle. In modern times, they are collected by children and young women from the narrow bee-barns that so picturesquely dot the countryside, and are generally boiled and eaten with toast or used in baking. The larvae of the bee are harvested later and often cooked in a stew of their own jelly with saffron, honey, and wild garlic.

The typical country bee-barn found in Scotland is a tall, wooden building, with low gaps around its base to admit its busy inhabitants. The humans who enter by the door find themselves in a maze of dark passages full of sweet smells, hypnotic buzzing, and the enveloping warmth generated by the bodies of the honeybees who nest in the hexagonal cells that line the walls from floor to distant ceiling. These places are integral to the mellow charm of rural life, but such farms are vanishing from the countryside as more and more people migrate to the safety and convenience of the industrialized city.

Hymenopterans other than the bee are infrequently domesticated on a personal scale here on our Northern island. Ants, as I have mentioned, are typically insular, and despite their undoubted utility, they are far more often used in industry than upon the farmstead. Honeybees can be playful, and a worker bee sometimes enjoys pausing in the course of her daily duties so a child may scratch the coarse fur of her abdomen. No-one would think of doing the same with a wood-ant, profitable though they be in their own way. An ant has a cold disposition and is quick to anger. More

fearsome even than the social ant and even less suitable to domestication is the wasp. No wasp or hornet will ever find his way to the gentle husbandry of the farm. The empty nests of some wasps can, however, be raided by brave adventurers for the fine paper from which they are built, and thus, these dangerous creatures contribute to our prosperity and comfort, though it be against their will. These creatures have their utility, however limited in scope or difficult to obtain it may be, but there are other members of the order Hymenoptera whose entire existence is anathema to us. Ichneumon wasps and other parasitoids bear little resemblance to our gentle, utilitarian honeybees, and their malevolent visages and slender, demoniacal ovipositors haunt our nightmares. That these hideous creatures are cousins of the beasts that serve us so well is a fact that is outrageous almost beyond reason.

THE BEETLE

This most diverse, successful, and powerful arthropod is all things to all men. There are, according to some of our natural philosophers, hundreds of thousands of species in the order Coleoptera, and the services they render to mankind are nearly as numerous as are the varieties of these creatures. I have chosen to approach the beetle as an entire order, rather than forming chapters based on their family or function because, were I to make such divisions, you would now be reading a book comprising nothing but chapters about beetles and their history. This order is so numerous that it is nigh impossible to pass from morning 'til night without happening upon at least one of its members, be it a miniature version of the helpful lady beetle creeping through your garden or a full-sized longhorn drawing a hansom cab over the cobbles of the high street.

The enormous variety present in Coleoptera uniquely suits this order to service under man. There are flying beetles and flightless ones; deliciously squidgy beetle larvae and hideously poisonous blister beetles; beetles that can run fast and true and ones that lumber aimlessly on legs that seem too frail for their enormous bodies. My estimation finds that here in Britain we have domesticated in the range of eight hundred and fifty species of Coleoptera, which is a mere fraction of the beetles that roam wild throughout our nation. The number of domesticated beetles leaps by an order of magnitude, however, if we include the rest of the world in our accounting. Those who live in the prosperous island nations of the South Pacific are said to have found a use for, and thus conquered nearly every variety of beetle discovered in that part of the world. The Culhuan Empire is understood to have domesticated around a tenth of their fifty thousand native species.

Every part of the beetle's exoskeleton has been used by man and for nearly every purpose. Beetles draw genteel ladies through the countryside in beetle-carapace carriages. The walls of our clubs are lined with wainscoting made from their textured plastrons. The wild-found beetle carcase means that no man must sleep in the rain, but that every beggar carries with him, in the manner of a snail, his own shelter. It is an obvious fact that the beetle is a domestic animal, but unlike the affectionate centipede, the docile bee, or the

Opposite page: A farm girl ponders a sleeping grub in this illustration adapted from one of George Morland's paintings of rural life.

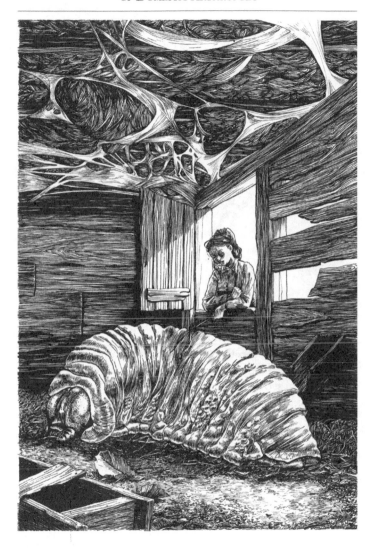

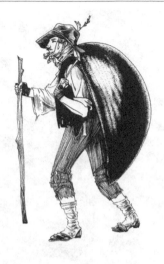

loveable bluebottle, their relationship with their human masters is less characterized by friendship than by utility. This may be because most beetle species are undemonstrative and have little character. They are, however, usually gentle and pliant and make quite useful helpmeets.

Numerous other members of the order are cultivated by farmers in this and other countries, and it could be argued that the beetle is the single most important animal food source on the planet. Domesticated beetles can be found on every continent, and in every meat-eating culture, they are, in fact, ubiquitous. The first evidence of mankind's relationship with beetles was found recently in the Cueva de El Castillo in Spain in the form of ochre and charcoal cave paintings of animals that look rather like members of the Carabidae family. Once hunted in the wild, many beetle species were eventually discovered by early Sumerians to be well suited to domestication, and they became the first farm

Pictured above: A beggar carrying an elytra on his back is a common sight here in Britain. He carries his worldly goods beneath it and uses it to cover his sleeping form at night.

animal of what we think of as the Western world. It is not merely that these varieties are nourishing and have a pleasant flavour when butchered in the first stage of their development, but when full grown, these creatures are remarkably powerful and tireless. Beetles were the first animals ridden by man presumably because then, as now, when someone climbed up on his back, the early beetle just kept walking. By twisting ropes around the beetle's antennae, particularly those of the family Cerambycidae, the rider could induce the creature to turn in the direction indicated. This functionality eventually made the beetle the obvious choice to plough the fields once man embarked upon agricultural endeavours. Today in Britain, flightless longhorns are still used as draught animals, and many farms keep them for this purpose. Grain farming in this country traditionally incorporates beetle husbandry. On these farms, beetles are raised for both their labour and their meat, while the grain that is harvested feeds both beast and man. While the larvae and pupae on these farms are kept in their stone barns, cool and safe, the adult working beetles are a common sight, drawing the plough on a spring day or tethered in the fields of an evening. Many pastoral farms in hilly or otherwise less arable land raise beetles as a primary crop, often choosing species based on the rich beauty of their carapace. Even if a pastoral farm raises bees or silkworms as its primary herd, they might raise beetles in an auxiliary capacity since a variety of these can generally be found to thrive in most climates and subsist upon the most commonly available natural food. They are often raised to adulthood for use as pack animals or mounts. An interesting note about beetle husbandry is that, due to the extreme variety present

A Tudor Recipe for Mealworm

To dresse a wyrm the French manner. Take it and spit it, & lay it down to the fire, and when your wyrm is through warme, skin her, and cut her off the Spit as another wyrm is, and so divide it in twenty peeces more or lesse as you please; when you have so done, take some White-wine and strong broth, and stew it therein, with an Onion or two mixed very small, a little Time also minced with Nutmeg sliced and grated Pepper, some fine ant-flour and Elder Vinegar, and a very little royal jelly, and Gravy if you have it, so Dish it up with the same Liquor it is stewed in, with French Bread sliced under it, with Oranges and Lemons.

in order Coleoptera, one can travel for miles over the British countryside and not pass two farms that raise the same sort of beetle. Some farms keep rove beetles or lady beetles for pest control, some keep bombardier beetles as protection, and some keep sundry varieties of Buprestidae for their gorgeous elytra. These glossy black, red, or glittering metallic bodies dot the rolling hills throughout our pleasant island, and when I am in the city, it is the memory of this sight that draws my thoughts back to the countryside that I miss.

As we all know, the range of beetles raised by farmers for food is vast. I think it can be safely posited, however, that the larva of the darkling beetle is the most common meat that we consume here in Britain. Though they of course bear no relationship to earthworms, the larvae are often called 'mealworms' for their superficial resemblance to those great segmented beasts that live in the earth beneath our feet and because they are ground by house-wives into a fine meal that is used in every application from bread to porridge. Mealworms are also eaten whole, seared in a pan, boiled, or fermented and thus can also be an entire 'meal' in themselves. The mealworm is a dietary staple that can be found on the tables of people of all rank and class. Inexpensive enough for the common labourer to pack for lunch, it is not so humble that it cannot be found on the tables of kings. It was, in fact, a favourite food of King Henry VIII, who enjoyed it brined in vinegar.

The weevil, another member of this order, is also a common food in its larval stage. Not as rich as mealworms, the larvae of the weevil are considered to be especially nourishing and are beneficial in curing a number of ailments. Often cooked into

soups and stews, weevil larvae are generally served alongside whatever grain they were fed on in life, usually wheat, barley, or rice. Some of the species in the family Curculionidae are allowed to complete their metamorphosis, and the adults are used to control unwanted timber overgrowth on farms.

Though the flesh of the adult beetle is not commonly eaten, full grown members of the order Coleoptera are useful to their human masters beyond their functionality on the farm, even in death. Many species are raised specifically for their carapaces. Some of these are uniquely beautiful and are used for primarily decorative purposes. The green, iridescent surface that characterizes the curricle of a young dandy is a feature of the carapace of the rose chafer beetle, in one example commonly seen today. And though the chafer is frequently slaughtered for its lovely elytra, it also, once its wings are clipped, is a sedate and dignified mount for ladies of the higher orders. The glossy scarlet elytra of the ladybeetle is used for many decorative and functional purposes around the home and is traditionally used to make baby cradles, particularly in the South. These days they are most often seen as accessories for young women of fashion. Beetle antennae and legs, too, appear in ladies' millinery and jewellery, and have done for millennia. The family of beetles most popularly raised for the decorative properties of their adult bodies is the Buprestidae. In this family can be found a vast range of colours and patterns of glittering metallic elytra, and these, when harvested, are used in numerous applications from jewellery to coloured ink. In Bharatavarsha, the Buprestid wing shells have been used for centuries in fine textiles and paintings that fetch handsome prices in the shops of Piccadilly to this day.

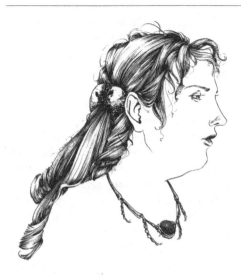

Buprestid jewelry is both beautiful and inexpensive. Here, a lady wears jewelry that features elegant beetle tarsi decorations.

The practical functions of beetle carapaces, however, are more important and have a longer history than that of any mere decoration. Military action has, since the beginning of recorded history, involved Coleoptera. When we in Britain think of taking up arms, especially in these embattled times, we often find our thoughts drifting to the hunt and the non-human foes who lurk in the dark wood and against whom we must ever be vigilant. But throughout man's long history, the sad fact of hostilities between members of our own species remains a constant. Beetles, particularly Scarabaeidae, have ever been a part of that.

Hoplites were Greek foot soldiers who used shields made of scarab elytra. These shields, often almost fully as

65

tall as a man, were used to protect soldiers in a phalanx formation. The soldiers practiced their aggression upon each other by thrusting their spears out from between the individual segments of the shining, multi-faceted shell that sheltered them. Later medieval plate armour was made from the carapace of a scarab beetle that was soaked to soften it and then formed around the shape of a soldier's body. This was an elite form of body armour, worn only by cavalry in the beginning of its use in war. Because it was so light and yet could turn away even the fall of a heavy iron axe, it was ideal for mounted soldiers. Today's spider and wasp hunters still wear plates of the carapace of the scarab, as well as the more iconic red shell of the cardinal beetle, to fend off the thrust of the ovipositor and stinger. It is the carapace of the scarab beetle that has always been the most highly sought substance for use in armour plating. As they were the animals generally believed to be garbed in the hardest and lightest of all exoskeletons, the family Scarabaeidae, though the most peaceable of insects, have always been associated with war. Though the carapace of the scarab beetle has always been the most highly sought substance for use in armour plating, later medieval and renaissance soldiers wore armour made of the exoskeleton of a wide range of animals, including bumble- and honeybees, crickets and grasshoppers, and—though this would make members of our own society shudder—even the plates of the common centipede were sometimes used, strung together with wire rings. Some Mediterranean warriors used crab and lobster shells to protect their bodies in battle, for these were so plentiful, but these were widely thought to be too brittle and rigid to be practical.

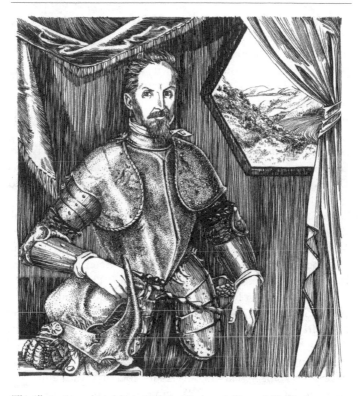

This illustration, adapted from a painting of Antonio Treus of Undine by an unknown Italian master, admirably demonstrates the use of Oryctes nasicornis *armour. The carapace has been carefully formed to the wearer's body and retains some of the furry interior of this beetle's exoskeleton for padding. Note the sword belt made from the filiform antenna of another species of beetle, likely one of the Chrysomelidae family.*

While we quite naturally eat the flesh of the beetle and wear his powerful exoskeleton as armour, he also serves us in life. As I mentioned previously, longhorns are yoked for ploughing and are ridden by men and even women of all classes, and chafers are a genteel mount, but most of my readers will be familiar with the beast most sought after to to pull the carriage of a young dandy, the bulbous-eyed tiger-beetle. These odd looking animals are not native to Britain, but were brought to our island over the years by visitors from a variety of tropical lands and were subsequently bred for speed and obedience. To those who are not accustomed to such creatures, they can be rather alarming. But, as most responsible tiger-beetle keepers keep their animals muzzled, there is little to fear from these nimble predators.

The bombardier beetle, another member, together with the tiger-beetle, of the Carabidae family, has been domesticated in Britain as a home defence measure. These unfriendly animals are kept solely to protect property from burglars and other criminals and can be seen patrolling with their heavily armoured human handlers near banks and government buildings in the evening. The ethics of intentionally bringing this animal into cities is a topic that is widely debated by concerned citizens at all levels of society. Walk into any pub, or into the halls of Westminster, and you are likely to eventually hear a voice deploring the violence that these creatures engender in our lives or justifying the usefulness of them. Bombardier beetles have historically been used by combatants against one another in wars in every part of the world, and using them to deter civilian wrong-doers is seen by some as overzealous. These beetles can be quite difficult to

control and have burnt innocent people on several occasions, frequently with the result that the victim expires. The burning chemicals expressed so explosively from the abdomen of the bombardier beetle are extremely painful to the eyes and injurious to the respiratory system and, if deployed, can affect passersby at a distance of two or three city blocks. As most of my readers will likely have a strong personal opinion on this topic, I shall strive to keep my own thoughts to myself in order to prevent undue strife. There is, however, at least one use of the bombardier beetle upon which most of us can agree. As the parasitoids of this country increase in number, and men and women find themselves unable to escape from the cruel and horrifying thrust of the ovipositor, even, in some cases, within the safety of the city walls, the domestication of bombardiers has been a boon. It was only this year that an enclave of braconid hosts was found near Kensington, and when rescuers discovered that the larval creatures growing within the bodies of the unfortunate victims seemed to have gained control of their hosts' limbs and were reacting in self defence, a group of constables were able to defeat them with the blasts from a handful of bombardier beetles.

Another important beetle with a unique position in our history is the sexton beetle, a creature domesticated even before the dawn of civilization. These animals have always been with us to bury our dead and keep human settlements free of disease and the visible signs of mortality. It is a comfort to many to know that the body of their loved ones are, in a final act of sacrifice, feeding the young of this somber genus of beetle, and in so doing returning to the bosom of the earth. Some religions throughout the ages have eschewed

Sexton Beetles are a common sight in cemeteries.

the use of the beetle, notably the Ægyptians, whose dead still lie, undecayed and magnificent, in the mighty Pyramids of that nation, but most cultures have seen the wisdom of employing the sexton beetle in his melancholy task. Forbidden by some denominations of Christianity starting in the 15th century, the popularity of the sexton beetle was revived in Europe after the Black Death annihilated a large portion of the population of the continent and of Britain and Ireland. Most of my readers have almost certainly attended at least one cemetery service and are familiar with the associated rites, but still, it is interesting to make note of some of these traditions. The hearse is nearly always drawn by sexton beetles or another variety of carrion beetle. Since members of this family are generally rather small, often no larger than knee height, ten to twelve of these beetles are often employed at this task, and resemble a glossy black and yellow swarm pulling the carriage through the streets. Christian burials must, of course, take place on consecrated ground, and most churches supply several brooding pairs to communally bury

the body, which has been placed in a thin wooden coffin for the modesty of the deceased. The sexton beetles commence digging a hole under the coffin, a process that can take several hours. When they have completed this, they mound soil on top of it, and complete their task underground. This includes depilating the body, covering it with secretions, and laying their eggs in the coffin. A fortnight will usually pass before the young beetles emerge from the soil around the gravesite and are recaptured by the sexton so that the process might begin again. Sentimental family members may occasionally return to the gravesite after the service to catch one of the young beetles that were nourished in the body of their loved one.

There is great variation in the sizes of members of the order Coleoptera. The Goliathus beetles, in the family Scarabaeidae, are so large that individuals of this genus brought back to our British zoos by explorers are unable to walk through a barn door at their largest adult growth. When situated in their natural jungle habitat, these beasts can grow to be as large as a house. They are not agile walkers, however, and are therefore only ridden under special circumstances. Due to their strength, goliath beetles do belong to the variety of beetles that can carry human passengers through the air, despite their enormous size. Most beetle species are terribly clumsy fliers, as we all know, for who among us does not observe with alarm the first june beetles of the season, who crash their heavy bodies so loudly against the windows on a summer evening in their eagerness to reach the light? This clumsiness ill suits them for manned flight, but if the ancients are to be believed, several species of beetle were ridden into battle

in the wars of the past. In the battle of Marathon, Persian cavalry were mounted in such a way on their Coleopteran steeds that a portion of them were able to launch into the air above the Greek soldiers and rain arrows down upon them. This surprise air attack was less successful than it might have been expected to be for two primary reasons. The first of these was that the Athenian soldiers were able to redirect their phalanx defences skyward, preventing the mounted archers from causing them any injury. The most important reason why this air attack failed, however, was that the beetles, likely rhinoceros beetles, failed to keep their riders upright and often crashed heavily in the midst of the opposing army. This is likely why modern armies so rarely attempt mounted beetle flight in their maneuvers.

A more successful and very astonishing use for the very largest flying beetles can be seen in Kanem-Bornu, where the *Goliathus goliatus* is found at its full size. The more adventurous inhabitants of that country will build small settlements on the pronotum of this enormous beast, who flies to more richly foliated areas after depleting the previous one of sap and brings his human cargo with him. This is an effective way for these riders to explore new and abundant ecosystems, but it is quite dangerous, and only the bravest attempt it.

Another extremely popular and useful family of beetle is the Lampyridae, called glow-worms in Britain. We know little of how prehistoric man lived, but based on cave paintings and grave-goods unearthed by archæologists, we can guess that the earliest humanity used the remarkable glowing bodies of these singular beetles to illuminate the night long before written memory, perhaps before the discovery of fire. While fire is

in most instances more useful than the glow-worm as a light source, since fire can also be used for warmth and cooking, in many places this soft-shelled animal companion still lights up the night. The fireflies of Misi-ziibi are particularly marvellous, for they can dart through the air as our glow-worms do not, and early summer evenings in that country can be so full of these creatures that the night transforms into a bizarre greenish facsimile of day. Their larvae are sometimes kept in glass terrariums mounted at intervals along the streets and take the place of gas lamps in summer, as is also done in some Southern British cities. Some households also keep one of these helpful beasts in a basket in the hall to serve as illumination in the event that someone must rise in the night.

Coleoptera may, as we have seen, be large enough to house multiple people on their backs, but they can also be as small as the nail on your little finger. That some of their number can produce light from their bodies or act as a chemical cannon shows them to be nothing short of miraculous. The beetle is arguably the most important resource that mankind draws upon in his daily life. It is impossible to imagine life in Britain without this diverse and astonishing order.

THE SILKWORM

The silkworm's place is unique in modern animal husbandry. While the caterpillars of other insects are generally raised as food animals and rarely reach the age of cocoon building, the silkworm is cultivated specifically for its cocoon. The young caterpillars of the silk moth are raised on mulberry leaves and in comfort until they weave their silky nests. But only a fortunate few are destined to awaken from this cosy slumber. The luxurious fibres of the cocoons are harvested soon after the beasts begin their metamorphosis. This is achieved by the simple expedient of boiling the cocoons whole, thus in one step loosening the fibres of silk, which can then be unfurled, and ending the life of the pupa, whose rich flesh makes a traditional harvest meal for the farmhands.

A silk farm at harvest time is a fascinating place to be. The boiling cauldrons send clouds of steam into the night sky, and the silk farmer, illuminated by the fire below, stirs the silk with a giant paddle, drawing it out of the churning liquid in huge, dripping hanks. He hangs these on racks to cool, and soon the women spinners collect the silk to unreel into smooth, untangled filaments. The spinning requires a spacious workspace since each filament is extraordinarily long, some reaching lengths of up to ten miles. In the past, silk unfurling required multiple women moving back and forth across the floor pulling the silk with them in a process that resembled a dance. More recently, modern mechanization has provided us with great clanking machines that can be operated by a single woman and that unfurl the silk with almost the same dexterity as does the human hand. But while many modern innovations can be beneficial, often, indeed, vital to our current way of life, this chronicler prefers the old ways in this instance. The woman sitting alone with her machine must feel lonesome when she compares her lot with those of the women who rejoice in the communal practice of unfurling the old way.

Silk that is going to be used for ropes and nets and in other rough conditions is ready to use after the unfurling, but the delicate silk used for ladies' dresses still has another step before it is ready to be dyed and woven. This silk is washed in hot soapy water to remove the sericin or adhesive that the worms used to keep their little nest together. Once the sericin is washed away, the resulting silk is soft, shiny, and ready to be made into the highest quality gowns, and ribbons, and even warm jackets and shawls.

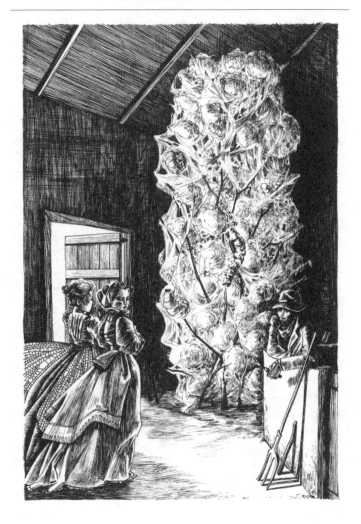

Although silk of varying quality can be derived from numerous animals, most notably arachnids, the silkworm, called *Bombyx mori* by the Romans, is our most beloved fibre producer. The tiny, spiky worms that begin to hatch from their tea-cup sized eggs in late spring stagger lazily around in the safety of the barn, seeking the piles of mulberry leaves that they must consume immediately once they emerge. Children love to be the first to pitch piles of soft leaves into the worm enclosure, and then listen carefully as the little creatures commence producing the gentle nibbling sounds that we associate so closely with innocence and youth. As they grow, of course, their volume becomes louder, as their bodies become larger. A farmhand must be nearby at all times while the worms are young, to add leaves to the hungry animals' enclosure, so there is always someone present to witness the 'praying' of the silkworms as they rear up and prepare to moult. The worms themselves must not, of course, ever be touched, save in an emergency, because their skin is so fragile, but those who long to stroke the softness of the worms' skin may content themselves with the moult castings. Once the worm has split his skin and stepped neatly out of it to dry his damp new instar in the warm air, the kindly farmhand might pluck the casting from the pen and offer it to a curious stranger or a hopeful child. The casting is soft and light, and covered with a fine down that foreshadows the useful fibre

Opposite page: An impertinent farm-hand addresses two ladies who have come to see the origin of the silk that composes their elegant raiment. Too few of us can say that we have visited such an interesting place, and we are the poorer for it, for the silk farm possesses many attractions.

77

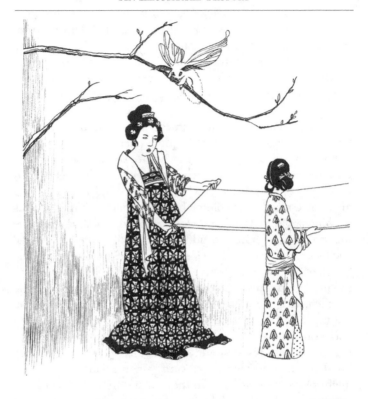

Emperor Huizong painted Court Ladies Preparing Newly Woven Silk *in the early part of the 12th century, based on an even earlier painting by Zhang Xuan. This illustration is adapted from a detail of that painting, and depicts a peaceful scene of women clad in elaborately embroidered silks and engrossed in their graceful task. An adult* Bombyx mori *looks on, rather precariously, from a tree branch.*

that is yet to come. This delicate cast-off seems at first to be as strong as silk fabric, but a little use reveals its delicacy, and these moult casings are often given to children to play with until they inevitably disintegrate into soft dust, generally within a few hours of use.

Sericulture is ancient, and for centuries it was practiced only in China. Empress Xi Ling-Shi is credited with the discovery that the cocoon of the silkworm could be unravelled into strong, beautiful thread. Over three thousand years ago, in the Empress's time, silkworms were much smaller than they are today. They were so diminutive that one of their caterpillars could curl up in the palm of a human hand. In this tale, Empress Xi Ling-Shi was in her garden enjoying a cup of tea. Above her in the branches of a mulberry tree she spied a soft, white cocoon with a beguiling halo of errant threads. When she reached up, longing to touch its fluffy surface, she accidentally knocked it into her cup of tea. The cocoon was so small that it barely filled the cup, and tea splashed over the rim, and soaked into the fibres of the cocoon. When the Empress, in alarm, rescued the cocoon from the hot liquid, she found that it was beginning to unravel. She unwound the long, shiny thread, looping it around her hand, and realized that it was continuous and unbroken. Though many countries now practice this graceful art, all right-thinking silk lovers remember with gratitude its ancient progenitor.

The practice of silk farming spread throughout ancient Bharatavarsha and thence to the Byzantine Empire, where it became a staple in the Western world in medieval times. Even after Europeans started practicing their own sericulture, silks from Bharatavarsha and China remained prized imports

due to the beauty of their weaves and dyes. Often British silk is referred to disparagingly by merchants and society ladies alike, and it must be owned that our silk fibre is of a rougher consistency. But give me plain, hearty British silk any day, for no other kind makes a warmer jumper or stronger rope.

ANIMALS IN RELIGIOUS PRACTICE THROUGHOUT HISTORY

Animals have always played a large role in the religious practices of mankind. Indeed, nearly every ancient religion from every part of the world has incorporated elements of animal worship. In some instances these have manifested as appeasement rites that required their followers to perform sacrifices to the wild and predatory beasts that plagued them for man and beast have been, in many ways, locked in violent struggle since man first left the Garden. Our history also includes, of course, many examples of mutually beneficial relationships with animals in which they serve us gladly, and these animals have also been important to devotional practices. Today Britain is a Christian nation, and most animal worship here is considered passé and heretical. But even Christianity contains tales of domesticated animals that instruct the faithful in religious virtues, and our history

includes the domestication of animals for sacred functions. Medieval monks who sought God through self-mortification carried fist-sized fleas with them to feast on their flesh, and though today we might find the thought of this practice repellant, it remained in observance in parts of Europe through the 1850s. Mayflies have long been a symbol of the fleeting nature of human life, and our promise of heaven to follow. And, of course, the bee remains a timeless image of humility and service to God. Overall, however, Christianity takes a dim view of the animal kingdom. The Holy Writ tells us that

> God said, Let us make man in our image, after our likeness: so that he may reign in strength and power over the crustaceans in the dark sea and the flies in the heavens, over the beetles and all the wild animals, and over all the creatures that move along the ground and beneath it. So God created man in His own image, in the image of God created He him; male and female created He them, only two. For the beasts were many, a hideous multitude, and man was set apart from this swarm. And God blessed them, and God said unto them, Be fruitful, and multiply, and replenish the earth, and subdue it: and have dominion over the krill of the sea, and over the flies of the air, and over every living thing that moveth upon the earth.

It is important for us to remember that we are the image of God upon the earth and that the beasts, helpful and affectionate though they be, have a naturally more sinful nature that corresponds more closely to that of the Adversary.

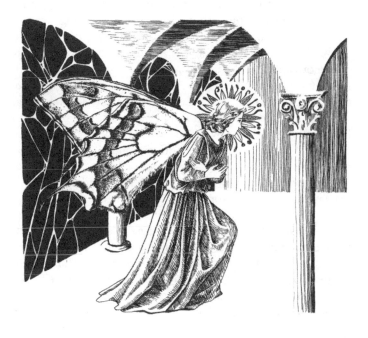

This illustration has been adapted from a detail of Fra Angelico's Annunciation. *Angels are frequently depicted with the wings of butterflies.*

There have ever been, throughout history, religions that require sacrifices on the altars of predatory gods. Even today, mad street preachers insist that ancient deities have sent the plague of parasites, the braconidae and ichneumon, to our land and that the hornets that swarm in the south of our island and throughout Europe are massing because we have failed to sacrifice the requisite number of virgins to them. These are times, certainly, in which we face what is truly a 'hideous multitude' of perils, and such danger is met with nobility and sacrifice by some, whilst others retreat to bizarre and absurd notions. But as rumors of parasitoid possession are continually confirmed in the newspapers, and brave men lose battle after battle with our vespidae antagonists, these aberrant perspectives have become common even among the great and good.

The Ancient Mesopotamians practiced the earliest recorded appeasement of predatory gods. The primary deities in this tradition were relatively benevolent, but some of them had offspring that took the form of foul, demonic demigods to whom ritual sacrifice was sometimes deemed necessary. Lamashtu was one such demon. Daughter of Anu, an ancient sky god, Lamashtu appeared as a bestial hybrid with the furred thorax of a tarantula, the slender waist and ovipositor of *Echthrus reluctator*, and the large black wings of a damselfly. Her face was that of a woman, but when she opened her mouth, the jaw extended into a labial mask like that of a dragonfly nymph. This demon would possess her victims, often giving them the appearance of pregnancy. When it came time for the victim to give birth, however, parasitoid larva would spring forth from the womb. Exorcism was frequently performed

via rituals involving bread soaked in water, a circle of flour drawn upon the floor, and exposure to the symbols of benevolent gods. Though it is unlikely that human sacrifice to this goddess was performed in ancient days, modern sects who have resurrected this religion through the millennia have sometimes performed such rites in times of great darkness.

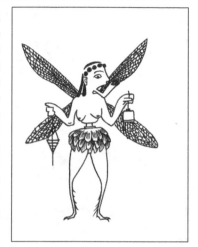

Devotees of a Greco-Roman mystery cult that was brought to Britain in the 500s performed a form of sacrifice that remains familiar to some farmers to this day. Adherents would leave the first young of a bee season chained in the woods as a gift for Arachne, princess of the spiders, in order to keep the rest of the flock safe. They believed that they could read portents of the future in the tangles of cobwebs at the forest's edge, and if the princess was pleased, she would write a message of prosperity for her people in the festoons of silk left behind by her dreadful webs.

Some religions contain animal gods that are portrayed as neither wicked nor purely good. A North American religion that was first practiced in Oceti Sakowin, but that seems to be spreading even to Christian lands in these days of free and open commerce and travel, recognizes Ikto'mi, a spider-like

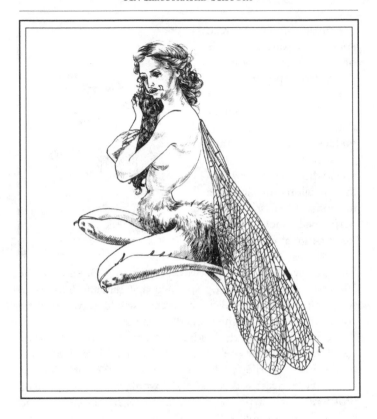

Previous page: An illustration of Lamashtu adapted from an engraving on a Bronze Age amulet shows her stylized form. Above, the same demon is shown in a more modern style, as adapted from the 1882 John William Waterhouse painting. In both images, the labial mask can clearly be seen distorting the figure's mouth.

trickster god. This deity has a human body that was born from an egg but is also capable of manifesting as a spider or as any number of other creatures. As unpredictable as an arachnid, Ikto'mi appears sometimes in a beneficent capacity but sometimes bedevils those who surround him. There is a prophecy that predicts that Ikto'mi's web will someday cover the earth and all who crawl upon it, and whether this will be for good or for ill is unknown to all but the gods themselves.

A large swathe of early religions and cults were formed around benevolent animal species that provided primitive man with essential resources or involved animals at least peripherally. A splendid example of this relationship can be found in the worship of the Scarabaeidae in ancient Ægypt. This muscular and beautiful beast was cultivated both for its nourishing flesh and its impenetrable carapace. It was especially popular with early civilizations because it eats refuse, thereby performing the dual purpose of feeding a civilization and cleaning up after it. It is unknown whether the domestication of early beetles or their veneration in mythology came first, but some clues about the beginning of beetle worship are known to us. The scarab beetle was thought to have a mildly antagonistic relationship with the Ægyptian sun god Ra because of this creature's practice of rolling of refuse into a ball and pushing this ball across the horizon, to bury it for later use. Early men, seeing the sphere of refuse blotting out the setting sun in the evenings during the course of the beast's progress across the land, associated the sphere with a force greater than that of the sun, and the beetle was thought to be the cause of eclipses. This is why, even now, the superstitious among us think of eclipses as times of good

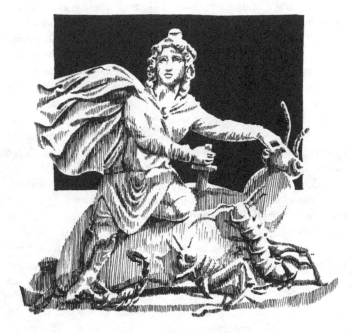

Statues of the Tauroctony still remain to pique our curiosity about the mysteries of the past.

fortune, plenty, and purity.

The Mithraic Mysteries of ancient Rome, and earlier of Persia, represented another facet of beetle worship in ancient times. One of numerous mystery cults that proliferated during the Roman Empire, the worship of Mithras, a mysterious

god who was associated with beetles, was practiced even as far west as Britain in the 5th century. The devotees of this specialized and secretive form of worship venerated the order Coleoptera in general, rather than just focusing on a single of its species as did the Ægyptians. This religion is thought of as a military cult, but since none of its writings have survived the vicissitudes of the centuries, this is only speculation. It is thought that the Mithraic interest in beetles had less to do with their general usefulness to the population and more to do with their use as cavalry mounts in antiquity and the function of their carapaces as armour, though more arcane meanings are hinted at by the strange idols that remain from this religion. Many of the secret underground meeting places of these cultists remain in Britain and throughout Europe as fascinating relics of a lost age. These Mithraeums were intended to resemble caverns dug out by some beetle species and were decorated by their members with strange esoteric symbols and images. The most iconic image associated with this ancient cult is the Tauroctony, a scene of the killing of a beetle, executed in a fresco, relief, or sculpture in the round. In this representation, the origins and meaning of which are shrouded in mystery, the god straddles a member of the genus Carabus, though the species varies somewhat in different depictions. He pulls back on the beetle's head-case, ignoring its antennae, and, rather improbably, plunges a knife through the hard shell of its elytra while a host of other animals looks on.

Flies were also represented in early paganism in important ways. Unlike beetles, flies were not revered for their usefulness. Even in primitive societies, flies were rarely eaten nor used

for resources. Perhaps because they seemed to volunteer to join human society rather than being conscripted into service, humanity has always had a deep affection for flies. Our current favourite, the bluebottle, is not so different from the house and temple flies of ancient Ægypt and Greece. The loud humming that, when made by a single fly in a cosy household, is the sound of peaceful contentment, was amplified by our ancestors, who gathered large swarms of these creatures together in temple courtyards. The sound of dozens of flies singing in chorus together is a sensation that even those who have never experienced it can likely imagine. Pytheas had this to say about the sound of the bluebottle temples:

> From nearby hills, as one approached the city of Amphipolis, one could hear the unceasing drone of the flies in its temples. The sound, increasing in volume as the listener approached the city, pierced into the minds of some visitors and drove them away or drove them mad. As I approached on foot, the sound seemed to swell my heart and fill me with joy. Upon entering the city and speaking to its inhabitants, I learned that many who were born in the city never noticed the sound at all. I had intended, in the course of my search, to learn the secrets that move men closer to the gods, to enter one of these temples, but even with the cocoons of the local Bombycidae wrapped around my head, I could not bear the sound even at the doorway

of these places. I was told that the acolytes of the cult of Diptera are trained to ignore the sound of the flies during the course of their daily lives. When they then, at prescribed times, divest themselves intentionally of this training and surrender themselves to the droning of the flies, it sends them into a religious ecstasy through which they receive celestial messages.

Those who work in the fields and barns with bees can likely relate to the transformative power of communal buzzing experienced by these ancient pagans, though the drone of a bee is lower in pitch and thus less troubling to the ears and soul than that of the members of the order Diptera. It is in part because of their loudness when singing in concert that flies are adopted at the pupal stage of their development.

Flies have also been revered in many cultures in their function as funerary insects. Indeed, there are many carrion species who have been considered sacred due to their utility in this arena from the sexton beetles we still use today to the hungry blow fly. With us in life, our animal companions remain at our sides even in our graves. It is no wonder that man has, in spite of his dominion, looked to the beasts, at times, with reverence.

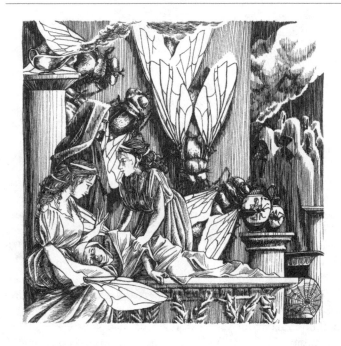

Acolytes in the bluebottle temples would go into noise induced trances during which, it was said, they were able to communicate with the gods.

THE DRAGONFLY

Named for the Greek *drákōn*, the mythological deep-sea worms that the ancients believed could swallow a fleet of ships in its whirlpool-like maw, the dragonfly is, in fact, a most useful and benevolent friend to man. The dragonfly spends his youth beneath still waters and can be seen motionless below the flat, cool surface of a summer doocote pool or marshy pond, catching prey with its astonishing jaws. Called a 'labial mask,' the dragonfly nymph's lower mouth extends a sharp set of pincers forward to surprise its prey, which is often nearly as big as he. Surprisingly large crustaceans and other underwater arthropods succumb to these serrated blades that thrust forward so unexpectedly, as, unfortunately, do human toes and fingers. It is always advisable, when paddling in still water, to plunge a pole or net into the water first, to see if an ambush awaits.

The dragonfly is a nymph for most of its life, supplying its human caretakers with meat and protection from underwater threats, but it is really for his adult form that the dragonfly is raised. When a dragonfly is ready for metamorphosis, he crawls out of the water onto a tree-branch or a doocote rail and breaks free from his nymphal exuvia. His shrivelled new body won't be ready to use for the better part of a day, and in the wild, dragonflies at this stage are in a great deal of peril from local predators. This, perhaps, accounts for why wild dragonflies are often smaller, and able to conceal themselves more easily than domestic ones, often growing only as broad in the wing as a human arm-span. There are numerous kinds of dragon and damselfly enclosures, the most common in Scotland being the doocote (a corruption of the archaic 'damsel cottage'). This building protects the young adult dragonflies as their bodies unfurl and harden. Whilst this process is occurring, shortly before the beast reaches its full size, the shrivelled young dragonfly is prodded by a farmhand or gamekeeper up the rail inside its enclosure, until it is settled within the attic of the little structure, where the adult dragonflies rest. When the dragonfly is at his full strength, training for the dragonfly's primary function in life may finally begin.

Dragonflies are special animals whose unique physiological features allow them to fly with great agility, speed, and strength. House-flies, bumble-bees, junebugs, and other flying beetles stagger and shamble through the air like drunken men, lurching into walls and tree trunks. Indeed, the rattle of the junebug's protective exoskeleton drumming irregularly against the stone walls and wasp cages of the city is a familiar sound

A snuff-box with a decorative dragonfly motif

that punctuates the droning hum of a summer's night. Dragonfly flight, in marked contrast to that of these clumsy beasts, is graceful and rapid. Dragonflies therefore are trained for long-distance communication and high-intensity hunting. They are relatively easy to train if fed by their trainer immediately upon assuming adulthood. Some farmers keep special drones in addition to their main bee flock for this very purpose, although sentimental people consider this practice barbaric. It is common for wealthy households to have a cluster of dragonflies, and communal dragonfly enclosures in city neighbourhoods and by village pumps give even those without the means to keep their own beasts the ability to send messages and small packages by dragonfly post. Doocotes in areas without farms often keep a supply of ants on hand to feed their own young insects. Social animals are quite convenient as feed, since they proliferate in such numbers, but many dragonfly handlers, seeking yet greater efficiency, feed their charges on a diet of pest animals such as moths and aphids.

Dragonflies have carried war despatches for centuries, but they also carry notes of affection to our faraway loved ones, and thus dragonflies are known not just for their martial abilities and powerful efficiency but also for their ability to connect us in friendship. Their mating practices are visually quite striking, and this too adds to the association of the

dragonfly with passion and fidelity. Shakespeare's iconic poem "The Damsel and the Dragonfly" reminds us of this relationship, and I include the final threnos here.

> Beauty, truth, and rarity,
> Grace in all simplicity,
> Here enclos'd, in cinders lie.
>
> Death is now the Damsel's nest,
> And the Dragon's loyal breast
> To eternity doth rest,
>
> Leaving no posterity:
> 'Twas not their infirmity,
> It was married chastity.
>
> Truth may seem but cannot be;
> Beauty brag but 'tis not she;
> Truth and beauty buried be.
>
> To this urn let those repair
> That are either true or fair;
> For these dead bugs sigh a prayer.

The image of dragonflies embracing can be found decorating the small trinkets that lovers give one another, such as little boxes and lockets. The heart shape that often characterises gifts of love is, in fact, alleged to have originated with the observation by Thucydides of the shape of dragonfly coitus.

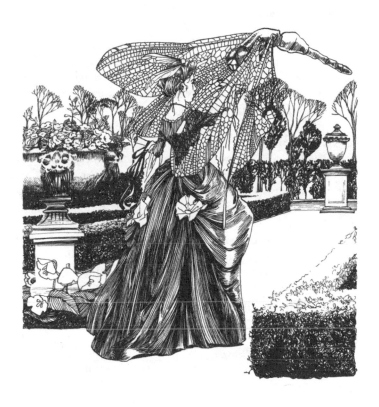

The Dragonfly's association with romance is well known. Here, a lady entrusts a private missive to her winged emissary.

Dragonflies are, of course, also fierce hunters. Fearless and predatory, dragonflies are an invaluable ally in our eternal battle against the wasp and hornet swarms that threaten our countryside. Because of their responsiveness to human commands and their bloodthirsty natures, dragonflies are called to join the hunt. Their wild brethren are frequently the quarry of such a hunt, and the sight of a powerful domesticated dragonfly defeating one of its smaller untamed cousins in an airborne death-match is truly astonishing. Adult dragonflies are also splendid hunters against a wide variety of other prey. They can be difficult to manage, however, since they are extremely prey driven and will lustily comence devouring a captured ant or cricket, no matter how thoroughly they have been trained. The master of the hunt must therefore be ever vigilant when hunting alongside dragonflies, and he will generally carry a special hook that can be used to prevent the beast from damaging his quarry overmuch. Of course, when the dragonfly is engaged against the most perilous foes, the vespidae and parasitoid, no such interference is necessary.

The variety in the dragonfly species is vast, even excluding their little cousin the damselfly. The small marshland fly that is hunted for sport has a vastly different appearance and function in society than the giant dragonflies that are now being bred in Britain for mounted flight, following methods that had previously only been used in Thai breeding programs. The experimental exercise anticipates a future in which men take to the skies on dragonfly back, giving us a greater freedom than we have yet known. Rarely attempted in Europe since the days of the Roman Empire, flight on dragonfly back is an historically dangerous practice, but

modern innovations lend greater safety to the practice so that someday it will be available to everyone. Our forays into this exciting new field have been modestly successful so far, giving us the first manned flight from London to Oxford. The subsequent flight, which attempted to reach Brighton, failed when the rider, Sir Hugh Catterpole, was blown off his steed and lost in the sea.

Following page: Though dragonflies are commonly used as couriers, it is unusual to see one on a lead in a city. Those who do keep such pets must have both a large garden and a high tolerance for gawkers.

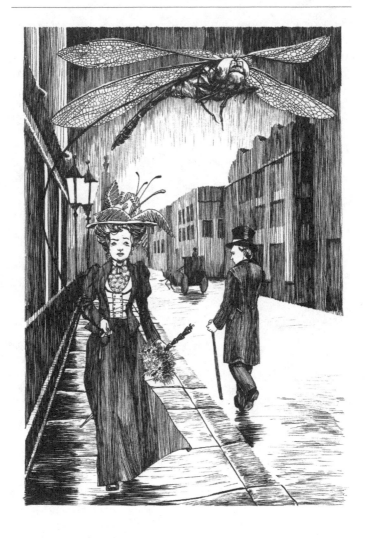

THE GRASSHOPPER

The story of how the grasshopper was first domesticated is not lost to history, as is the case with many of our domestic beasts, but is in fact a well known tale. Before the Hellenistic age, men rode all manner of beasts with little discretion. Even cavalry rode in on a member of the order Coleoptera until Alexander the Great made the bold choice to conquer the world mounted on grasshopper-back. His troops were at first sceptical when he insisted that they catch and confine six of these mighty creatures, scoffing that *"Aftá ta thiría échoun kamía agápi gia mas."* Alexander persisted, however, and his men, using hooks and ropes that have changed little in the intervening two thousand years, caught and bound the required grasshoppers. It took the next three days for the assembled company to devise bridles and saddle attachments for the beasts, during which time the men found

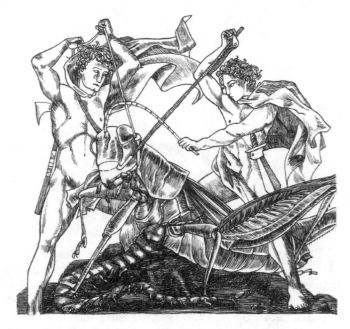

Here, Alexander and his loyal companion Hephaestion overpower a wild grasshopper with the assistance of a loyal centipede. After a Macedonian mosaic.

the grasshoppers surprisingly tractable, intelligent, and even affectionate. The first man to remain mounted when his grasshopper launched itself and performed its graceful passage across the heavens was Philotas, son of Parmenion.

His words on the experience were recorded, and the Latin translation from Curtius' *Historiae* became the motto of the British Equestrian Society: *Non solum domus mea est terra. Nunc sunt caeli.*

Throughout history, the global seat of power has resided in different places in the world. Four thousand years before Christ was born, the Nile Delta was the home of the most advanced civilization, and the power the Ægyptians wielded influenced the entire region for millenia. Later, the Greeks and Persians vied for power with the Chinese, with the Bharatavarshan kingdoms caught in between, but when Alexander undertook to conquer the world, he shifted the seat of power to Constantinople for less than a century. After his death, his empire fell, but his legacy remained in the grasshopper, which was almost immediately adopted as the steed of choice in the majority of Europe, Asia, and Africa. Of course, some regions retained their locally preferred mounts, such as, for example, the dragonfly riders of Thailand. In the Congo, too, the weaver ants upon which the locals heavily rely for manufacturing, transport, and food have always been more popular than any other mount. But every society that used Coleoptera as their primary form of transportation either adopted the grasshopper or were conquered by cavalry they had no hope of besting. Our own nation adopted this steed in the century before the birth of Christ, after Julius Caesar's unmounted legions soundly beat the Celtic Britons who fought from magnificent but rather ungainly beetle-drawn chariots. The ships carrying the grasshoppers that Caesar had hoped to ride into battle in these early engagements had been turned back by storms in the Channel, but when the Romans

finally brought them to the British shores, the beasts were adopted by the natives with alacrity.

Since early Britons adopted the Roman Grasshopper, this beast has been a fixture in every home with the means to maintain a stable, and it is difficult to imagine a Britain without this willing and powerful servant. A gentleman's home in rural England might house as many as twelve grasshoppers, which are used most typically for hunting. Gentlemen enjoy riding grasshoppers for pleasure as well as for sport, and in recent times, this pastime has been adopted by ladies of a rather dashing sort, who occasionally even go so far as to join the hunt when a particularly desperate struggle arises, and men are in short supply. The more demure members of the fair sex do still generally prefer to ride a member of the Scarabaeidae family, though, even in this reckless age.

UNDERWING SADDLES

FOR DISCERNING GENTLEMEN

The highest military authorities approve of Underwing Grasshopper Saddles over any other brand. For hunting and recreation. Safety and comfort are of paramount importance to us and to our customers.

Opposite page: A gentleman launches his steed over the church wall in his haste to return home in time for Sunday dinner. Riding a grasshopper can, on occasion, make even the most staid pillar of society forget his place and act like a boy again. Above: An advertisement for riding gear

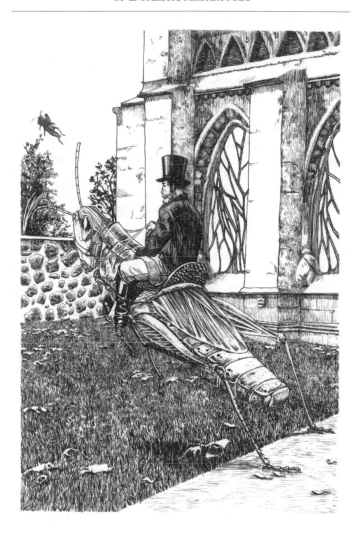

105

A peculiar feature of this useful insect is its bizarre history as a swarming locust. In times past, and in arid landscapes, the mild-mannered local grasshopper population of such a foreign clime would, on rare occasions, commence a horrifying metamorphosis. Transforming from gentle, friendly, green or brown animals into dark-coloured monsters via a series of rapidly occurring moults, the grasshoppers, who had become locusts, would break free of any enclosure and form ever more enormous packs which would eventually take flight, darkening the sky with the multitude of their bodies. These grotesque new creatures would reproduce with astonishing speed and, moving in concert as if together they formed a single creature, would consume every plant and tree in sight. These creatures instigated the biblical plagues and have been the cause of numerous famines throughout the history of mankind. Through both our good fortune and our ingenuity, we no longer face this particular form of adversity, for which we must certainly be grateful. The grasshoppers that Alexander tamed were of a variety that would become swarming locusts if moved by the spirit, which is almost certainly why they had not hitherto been chosen for domestication. The meadow grasshoppers that are the species most often domesticated here in Britain have a different, milder nature and will never turn into a fearsome gang of ravening beasts. A plague of locusts did swarm over parts of England in 1748, but this uprising was quashed before the beasts had time to depredate the crops to any devastating degree, and it is believed that the breed of grasshopper that committed this violence has long since been driven from this country.

To focus on the historical iniquities of this creature is, however, to do it a disservice. An affectionate, clever animal, the grasshopper is capable of learning many commands and of developing meaningful human relationships. Grasshoppers are also able to converse amongst themselves via a song produced by their back legs. This song can be heard at a great distance, and grasshoppers in separate barns and even on adjacent farms or enclosed in different city neighborhoods communicate with one another, though they are separated by walls and distance. Other Orthoptera, such as crickets, communicate in the same way, and are in many ways similar to grasshoppers. We have even been able to observe intelligence in crickets, and the occasional household that breaks with tradition and raises crickets has found them to be not contemptible as companions. They are less commonly beloved, however, and are more typically hunted for their delicious meat than welcomed into service.

THE SPIDER

No beast is more varied in size, breed, and nature than the arachnid, and none is the source of as much controversy. Those brave souls who keep a jumping spider as a pet argue for its gentleness and cleverness. The jumping spider is indeed soft and furry, with big, adorable, glossy eyes and a playful pounce. It is still a fearsome predator, however, like its sisters in the dark forest, and in spite of the insistence of its defenders on its affectionate nature, a poorly trained jumping spider has been the ruin of many a household. The people who assert with such vehemence that it is a wise idea to keep

Opposite page: While no-one can deny that jumping spiders are playful, dainty little beasts, they are still spiders and are therefore present a latent threat to all. Here, two children, unmindful of the danger, spend a lazy summer afternoon teasing their pet Habronattus.

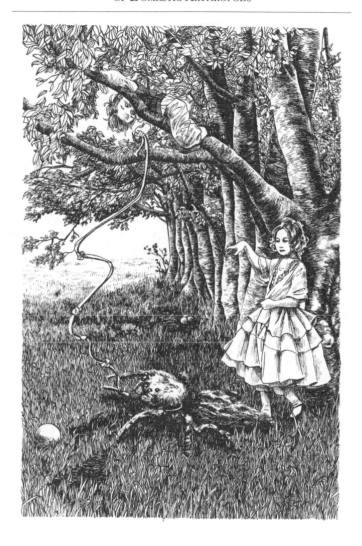

a spider in their home are also the sort to argue against the industrialized use of the spiders whose labour supplies us with such an extraordinary variety of silk that we could not now imagine life without them. The excessively soft-hearted may object to the brutal methods used to extract this useful product, but the modern world could not exist without these recent innovations in industrial animal husbandry. The spider, rather like various members of the family Formicidae, has not quite been domesticated but instead brought fully wild into the sphere of utility to man. The wild, monstrous arachnids who haunt the woods still remain in many parts of Britain, though they are fewer in number than in previous centuries. They are no longer the predatory multitude that haunts children's dreams, but even now they continue to provide sport to eager huntsmen in a few, ever dwindling counties.

Long thought to be too dangerous to domesticate, spiders were once entirely wild save for those small creatures who joined eccentric households as pets. It has become a rather expected thing for artists and members of the intelligentsia to adopt spiders, even those typically thought of as respectable. It will surprise no-one to hear that Lord Byron and Mr. Shelley kept a colorful male *Saitis barbipes* in their villa on Lake Geneva in the summer of 1816. They fed it scraps from their own table, and Mrs. Shelley (who was then only Mary Godwin) is supposed to have carried it around the garden in her arms, though it was near as large as a child of five. It was more confounding to the public when Elizabeth Gaskell revealed, in her *Life of Charlotte Brontë*, that the distinguished and fastidious lady's family kept a series of "bold jumpers" or *Phidippus audax* at the parsonage when she was a child.

The little girls were sent home [from school] in the autumn of 1825, when Charlotte was little more than nine years old. Their father, the wildness and peculiarity of whom I have already enumerated, provided for the entertainment and comfort of his children a small spider known as a 'daring' jumper. The girls and young Branwell named it 'Darling,' and it could be seen swinging from the chimney by those who passed near the house.

The family adopted another spider each year or so until Charlotte went back to school in 1831, and these odd little beasts figured prominently in the juvenilia written by the future authoress and that of her siblings.

Spiders were hunted to collect their pelts and to rid human neighbourhoods of these terrifying vermin, and their silk was only harvested when circumstances allowed. Their webs have always been dangerous to gather in the wild, but a unique trade in this substance has been the provenance of certain old ladies for centuries. The women who ply this trade—for it is still in practice in some parts of this country—discover, by curious means the locations of disused spider haunts and raid such places for the soft cobwebs found there. They sell their harvest to artisans who craft fine wares from the marvelous fibres. Spider web was therefore quite a rare and expensive material until recent times, which is odd to think of now. When, in 1754, Sir Henry Clithering devised a method by which a small team of workers could hatch young banded garden spiders and bind the females such that only their spinnerets were

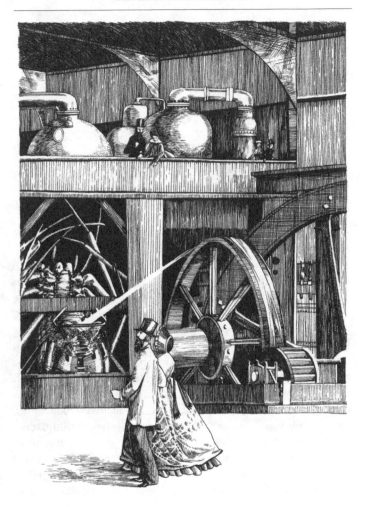

exposed, a commercial revolution began. The banded garden spider produces three distinct kinds of silk, which in the wild are meant to cushion and protect her eggs. After a complex process that tricks the spider into thinking she has laid, she will produce such a great quantity of each kind of silk that even though she expires almost as soon as she has finished, never to spin again, her level of production certainly justifies her keep. Men were quick to exploit other spiders following this discovery, and Britain alone now has industrialized seventeen distinct species of spider, including three tropical varieties that are housed in heated factories. These creatures supply us with adhesives that are strong enough to use in building homes and factories, as well as ones that are delicate enough to affix decorations to the delicate skin of ladies. They supply us with industrial-strength silk that can be used in the construction of buildings, and the soft cobwebby fluff with which we fill high-quality pillows and cushions. Inventors have devised all manner of clever extractors to collect even sheet webs, upon which ladies delight in embroidering delicate patterns, and which, in wildly different circumstances, brave hunters use to immobilize the vespidae and other, more hideous wasps. For, into the void left by the retreat of spiders from our woods and fields, a far more dangerous adversary has swarmed. Once, in this country, children were told delightfully frightening, fanciful tales of the eight-legged creatures that lurked in caves and in

Opposite page: This banded garden spider factory in Glasgow was on display as a model of its kind at the 1862 International Exhibition.

113

the tulgey blackness between the trees. Now the spectre that occupies these places is so terrible that no-one has the stomach to tell such stories any longer. The truth is more dreadful than could ever be matched by fancy.

THE HUNTER AND THE HUNTED

When we in Britain think of hunting, a familiar image springs to mind. The red-clad stalwart surrounded by his loyal pack is a figure that each of us has associated with this ancient sport since childhood (those of us, at least, who spent the formative years reading tale after tale of the exploits of his ilk in illustrated magazines and penny dreadfuls). But the hunter is not merely a symbol and not merely the province of little boys. Hunting for protection and the defence of human settlements has been practiced for millennia, and this fascinating and dangerous enterprise is unquestionably important to our continued existence. Pursuing creatures for their fur, their meat, and their carapaces is also an ancient tradition and is no less vital. The man who levels his firearm at a flock of dragonflies at dawn is no less a hunter than he who battles wasps in the murky forest evening. Indeed, those

who hunt from grasshopperback are not all wasp and hornet seekers. The spiders whose fur is worn by ladies of fashion are also pursued atop a grasshopper, as is the grasshopper's cousin, the cricket.

The history of hunting is longer than that of our other animal relationships, and in all of its modern iterations in this country, the act of hunting utilizes the help of domestic creatures. Inviting those essential companions—the grasshopper, the centipede, the dragonfly—with us into the fray nurtures a tricornered affiliation in which a hunter develops a stronger rapport with his antagonist animals and with his animal cohorts than he may ever have with another man.

The task of compiling a complete list of all of the animals that are customarily hunted in Britain would take many hours and pages, and I do not intend to attempt it here. The variety of beasts that are hunted for all purposes is vast because the variety of animals that exist in nature is vast, and it would be a futile thing to try to place finite borders upon it. The animals we hunt can, however, at least be broadly placed into three groups: beasts hunted for their resources, those hunted for sport, and the predators we hunt for our own self-preservation. There is, of course, much overlap between these categories. Take, for example, the case of the *Eratigena atrica* who were hunted here in Britain for centuries. These giant spiders were traditionally hunted for two primary reasons: to obtain their warm pelts and to keep the forests free of

Opposite page: Not every hunting excursion is a desperate contest. Indeed, few activities are more peaceful than the early morning pursuit of mature dragonflies.

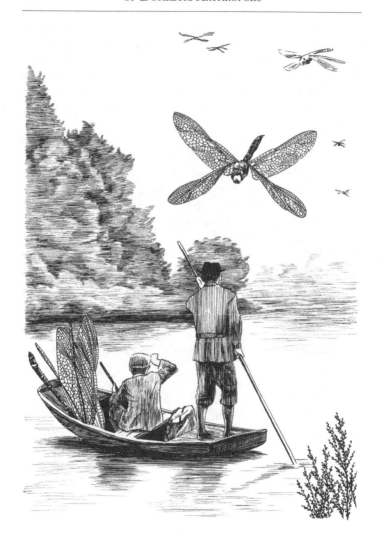

117

their dangerous influence. Though this variety of spider was generally peaceable, the awesome size and ferocious visages of these animals inspired fear in all men, and they were hunted without mercy. Though these spiders, like many of their class, can no longer be found in Britain, the nursery rhymes that have immortalized them as fearsome beasts of nightmare keep them alive in our memory.

Dragonflies and crickets are popular quarry who fall into the first group, as they are hunted for their tasty meat and their beautiful and enormous wings. Dragonflies are unusual in that they have a place as both hunter and hunted. Though they might join us in our battles against our Hymenopteran enemies, their wild brethren are quite delicious, and marvellous sport. Generally hunted from a flat-bottomed boat, or from the shores of a pond, the dragonfly and damselfly are favourites of the British game hunter.

Crickets are friendly and intelligent, and though they are occasionally domesticated, they are nonetheless an important target for game hunters. It is impossible to imagine the enormous fireplaces of the strongholds of old Britain without seeing a full-grown cricket rotating on a spit over the roaring flame.

In addition to these animals hunted for practical reasons, there are many beasts who are and have been hunted because they are beautiful rather than delicious, such as the unfortunate butterfly, who vanished from our hills so long ago. But outside her history as a quarry hunted for her wings, the butterfly also belongs to a long tradition of sport hunting.

In ancient Babylon, butterflies and exotic wild animal species were corralled into 'paradise parks,' fenced-in areas

through which noble visitors could pursue their trapped prey. Many early feats of architectural prowess were employed to this purpose, and these enormous caged areas still stand in some parts of the world, testaments to human ingenuity.

The Roman Coliseum is a later example of wild animals being confined and 'hunted' by men. This arena was significantly smaller than the paradise parks so that spectators could be ranged around the outside of the field and observe the desperate battles that took place within. A mesh barrier was of course arranged over the roof of the arena and between the audience and combatants. Strange contests took place in the arena of the Romans, between man and all manner of beast. The savagery of these contests was reported by Dio Cassius:

> When the gates leading to the underground cages were opened, a swarm of nine or ten hornets came buzzing out of them, immediately thrusting their bodies against the barriers between themselves and the spectators, who screamed in delighted fear. Other gates were then opened, revealing four men tied with ropes to *Papilio hospitons* imported from Corsica. The butterflies, in their fear, took to the air, and the men, hanging from the ropes below them, waved swords desperately about their persons, attempting, without hope, to fend off the violent attacks of the hornets, who, upon seeing the men, immediately transferred their attention to them.

The contest described by Dio Cassius did not end happily for its unwilling human and butterfly participants. The predators, despite the inequality of the contests and their inevitable victories, were generally destroyed before the event was over, for the entertainment of the crowds. After the slaughter, adequately equipped champions, mounted on dragonflies and clad in heavy armour, worked in skilled cooperation using hooks and spears to transfix the hornets, yellow-jackets, horseflies, and other menaces, to the satisfaction of the watching crowd. Earthbound monsters captured for these events in smaller, uncovered arenas included ants and spiders among other, more exotic beasts. While the upper classes were indulging in displays of bravery and cruelty, the common man continued to hunt for self-preservation. The Vespidae captured for the arena were caught by groups of champions working in tandem for the emperor, and they generally left the bulk of the nest intact for future use. Nests in the forests were protected in early Britain's history, following the custom held in the Roman Empire, and none were allowed

to destroy a wasp nest without the express permission of the ruler, though the wasps from a single nest are quite capable of perpetrating a devastating attack upon a village many miles distant. The cruel practice was halted during the time of Septimus after the Caledonian guerillas drove a swarm of *Vespula vulgaris* ·

towards the Roman soldiers by the expedient of torches and bonfires. The Romans then undertook to rid the land of wasp nests, for after all, there were no gladiatorial contests on this island, and the existence of the wild wasps was more trouble than good to them.

Mantises are one of the few insects that has continued to be hunted for sport in recent years, after a fashion. Moderately perilous quarry to pursue, they have little attraction for the table. They are generally sought by adventure-seeking youths of great houses who have no wish to endanger their persons overmuch, and in many stately homes throughout this nation, the head of one of these beasts may be seen occupying a place of honour over the mantelpiece.

It is against wasps, at least in Britain, that the hand of man has been raised most often in defense, and in recent years this eternal battle has grown ever more violent. Wasps of all stripes are hunted by man in order to rid our forests of these fearsome beasts rather than to obtain any succulent meat or furs. Of course, though, as in all things there are exceptions; paper has been harvested from empty paper wasp nests since before the art of paper making was common in Europe. In other lands, too, men sometimes seek to harvest goods from the bodies of the demoniacal members of the order Hymenoptera. In Sri Lanka, brave warriors have for centuries ridden out against the jewel wasp in order to collect her highly sought after and remarkably beautiful carapace. But the overwhelmingly urgent reason for hunting wasps is because they are murderously dangerous, and in order to keep our families safe it is our duty to keep them at bay. There

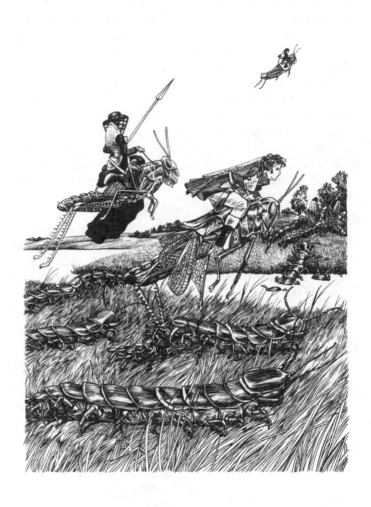

seem to be more wasps nowadays than have ever been seen before, and they have become emboldened, nesting closer to human settlements than ever in the past. Each species of wasp presents a different peril. The Vespidae that brandish poisoned stingers as sharp as swords are certainly a menace, particularly the social species, whose numbers are so great and whose fury is unmatched by any other creature known upon this earth. However, the beasts that are our most frightening foe, and against whom all of the weapons in Christendom are levelled, are the solitary parasitoids. Although not all parasitoid species target humans or our domestic creatures, all must be feared and fought, for they wield a power that no weapon made by man has matched: the ovipositor. A parasitoid wasp lays her eggs in the body of a host animal. This is often an animal without a hard cuticle protecting it, a category that includes caterpillars and other larvae, and humans. There are numerous ways in which a Chalcidid or Ichneumonid or Braconid, or any one of the seemingly ever-growing varieties of wasp larva may use its host, and all are monstrous. I will here elaborate on just one of these processes, in which the insertion of the ovipositor is done by stealth, and the victim is unaware of his now inevitable doom. The parasitoid, perhaps only the size of a fist, perhaps the size of a teapot, will fly quietly near her human victim and strike him on the leg or groin by inserting

Opposite page: The intrepid warriors ride out against their predatory foes in tradi-
tional scarlet lily armour. The lady who has defied social convention and joined the
chase wears sensible face protection, whilst the young blade at her side imprudently
goes bare-headed.

an ovipositor slender enough to cause little pain, and thus to pass unnoticed. If the victim is aware of the attack, he may have time to seek the assistance of a surgeon who, working quickly, can remove the eggs deposited in the victim's body before they hatch. Often, however, the victim is unaware that the ovipositor was inserted. Perhaps, while walking through a wood in the gloom of dusk, he failed to observe the dark form of the wasp darting near him. Perhaps he was punctured while he dozed in a meadow. However the attack occurred, the victim will afterward go about his business with good appetite and vigour for up to several weeks before declining into illness and retiring to bed. The wasp eggs have now hatched into larvae inside the victim's body and have been slowly consuming their host from the inside. When the larvae finally kill their host, it is in the process of emerging from his body. The larvae typically eat their way out of the poor victim's torso, and this terrible sight is always a dreadful shock for his family. The victims of such an attack are traditionally burnt on a pyre after death.

The men who protect us from these monsters do so mounted on grasshoppers, surrounded by a seething mass of centipedes, and like as not, accompanied by dragonflies who attack their enemies from above. Today's huntsman wears armour not dissimilar to that worn by his ancestors of a century ago. Innovations in the use of spider silk has improved the strength and comfort of these garments somewhat, but the beetle elytra plate of our grandfathers is quite good enough for us even now. Armed with swaths of sheet web or nets, spears, and torches, the hunters of today also carry shotguns and blunderbusses that expel gouts of Greek fire, which can

be very effective against wasps at close range. Because of the insidious methods by which many wasp attacks occur, a large quantity of liquor is traditionally consumed by the hunters and those of their animals that survive after the hunt. This is said by some to hinder the growth of wasp eggs in the body, but others suggest that it is simply to the hunter's advantage to think so.

Every time the hunter rides to his noble pursuit, he is supported by a legion of domestic beasts who supply him with the reinforcement he needs to protect each and every one of us, and we must all fervently hope that faced with this powerful and ancient cooperation between man and animal, our multitude of adversaries brandishing stinger and ovipositor will fall and trouble us no more.

Conclusion

During the creation of this volume, it has been borne upon me just how strange a creature is man. Among the fauna of this world, our body structure is unique, our soft, frail skin covering a bizarrely rigid internal skeleton, our upright gait, our sensitive noses and agile digits all singular traits. The only other backbones in our world belong to beasts long dead whose huge bodies have been discovered in underground places, and we humans are the lone living vertebrates on a planet teeming with animal life. To remember how staggeringly outnumbered we are by beasts so unlike ourselves might be, to some, rather disturbing. I shall suggest, however, that it is our strangeness itself that renders us fit to take command of this dominion that has been given us. Our exceptional bodies carry within them eternal souls and a capacity for intellectual reasoning and understanding that

far surpasses that of any other creature living. These, I posit, are as much an integral part of our peculiarity in the animal kingdom as our dexterous fingers and play their part, perhaps more than those appendages, in enabling us to grip the reins and exercise our dominion over our fellow creatures.

Acknowledgements

Millions of thanks to: Vivian French, Jane Hyslop, Michael Windle, Jonathan Gibbs, Cath Keay, Mark Blaxter, Mike Dye, Brooke and Chris Rynn, Lalainia Broers, Joey Hook, Louise Milne, Seán Martin, The Great Steward of Scotland's Dumfries House Trust, The Boswell Book Festival, and my fellow Masters of Illustration from the class of 2017 at University of Edinburgh. Thanks also to the folks at Paper Machine who helped me with this project very much, particularly Jessica Peterson (whose design advice was invaluable), Kiernan Dunn, Cheyanne Logan, Bob Snead, and Shana Griffin

Asia Wong, Robin Watt, Charlie Thorn, Lizzy Hamilton, and Isabel Burbeck helped with this project via advice and adventure. My dad, Doug Burbeck, collaborated with me in developing a material culture for this project, and my mom, Elsie Smith, offered help and advice. Parts of this project were exhibited in a variety of configurations at Big Blue Gallery in Iowa and Barrister's Gallery in Louisiana, as well as at the University of Edinburgh. Many thanks to all the folks involved in those excellent institutions.

Thanks to everyone at University of New Orleans Press, particularly Abram Himelstein, G.K. Darby, Chelsey Shannon, Leah Myers and Alex Dimeff.

Extra special thanks to Pasquale Cicchetti, Daniel Murphy, Moose Jackson, Richie Kay, Casey Cottrell, Asia Wong, and Elizabeth Hamilton, who read the book or various parts of it at various stages and offered so, so much help.